NATURE'S WISDOM

Coloring Our Beautiful World

ILLUSTRATED BY
MARGARET KIMBALL

Get Creative 6

New York

Get Creative 6
An imprint of Mixed Media Resources
19 West 21st Street, Suite 601
New York, NY 10010
sixthandspringbooks.com

Connect with us on Facebook at facebook.com/getcreative6

ISBN: 978-1-68462-012-8

Manufactured in China

7 9 10 8 6

First Edition

Introduction

Nature has long inspired artwork, poetry, scientific research, and activism. Great minds from around the world have written and spoken of the importance of nature in their lives and work. *Nature's Wisdom* gathers dozens of meaningful quotations that celebrate the beauty and wonders of nature.

Poet William Wordsworth revels in the delight he feels when beholding a field of golden flowers. ("And then my heart with pleasure fills, And dances with the daffodils.") Biologist and conservationist Rachel Carson reflects on the interconnectedness of nature. ("In nature nothing exists alone.") Artist Georgia O'Keeffe finds inspiration in flowers. ("When you take a flower in your hand and really look at it, it's your world for the moment.") Naturalist John Muir feels the irresistible pull of the wilderness. ("The mountains are calling and I must go.")

Each quotation is depicted in exquisite lettering that can be colored and is illustrated with gorgeous images that complement the quotation: leaves, flowers, exotic wildlife, forest creatures, birds, and more. Just as the dozens of artists, writers, naturalists, scientists, and thinkers whose words grace these pages were inspired by nature, you will be inspired to color these quotations and illustrations as you reflect on the meaning behind the words.

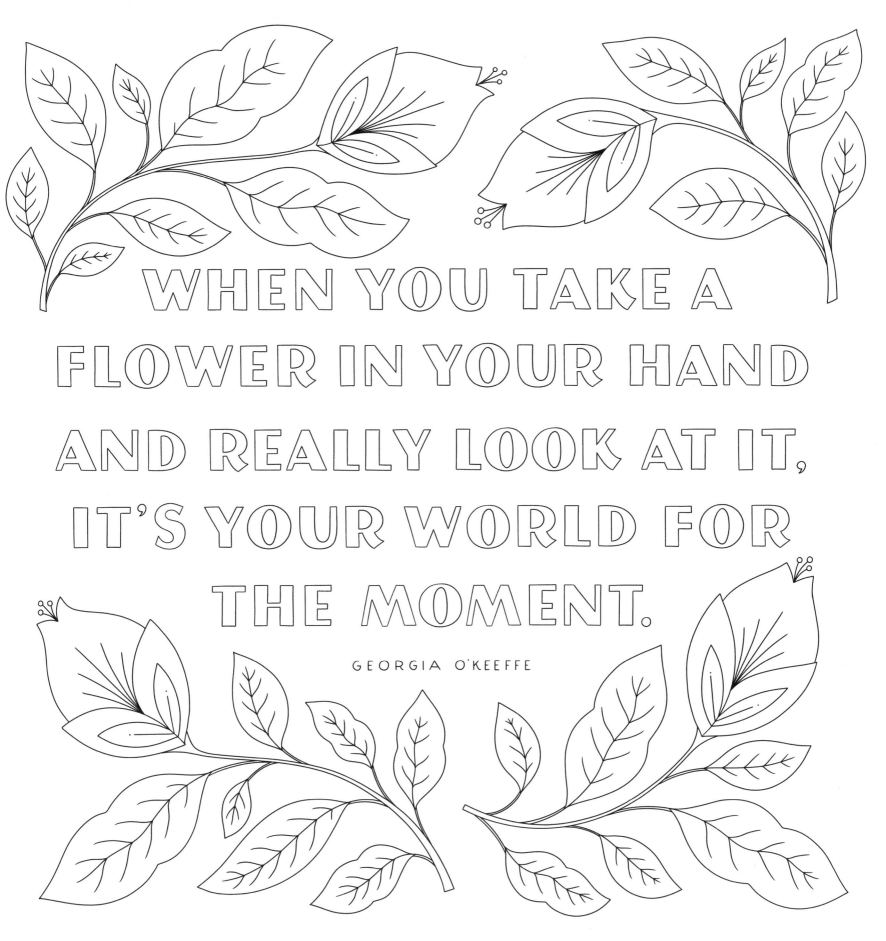

WHEN YOU TAKE A
FLOWER IN YOUR HAND
AND REALLY LOOK AT IT,
IT'S YOUR WORLD FOR
THE MOMENT.

GEORGIA O'KEEFFE

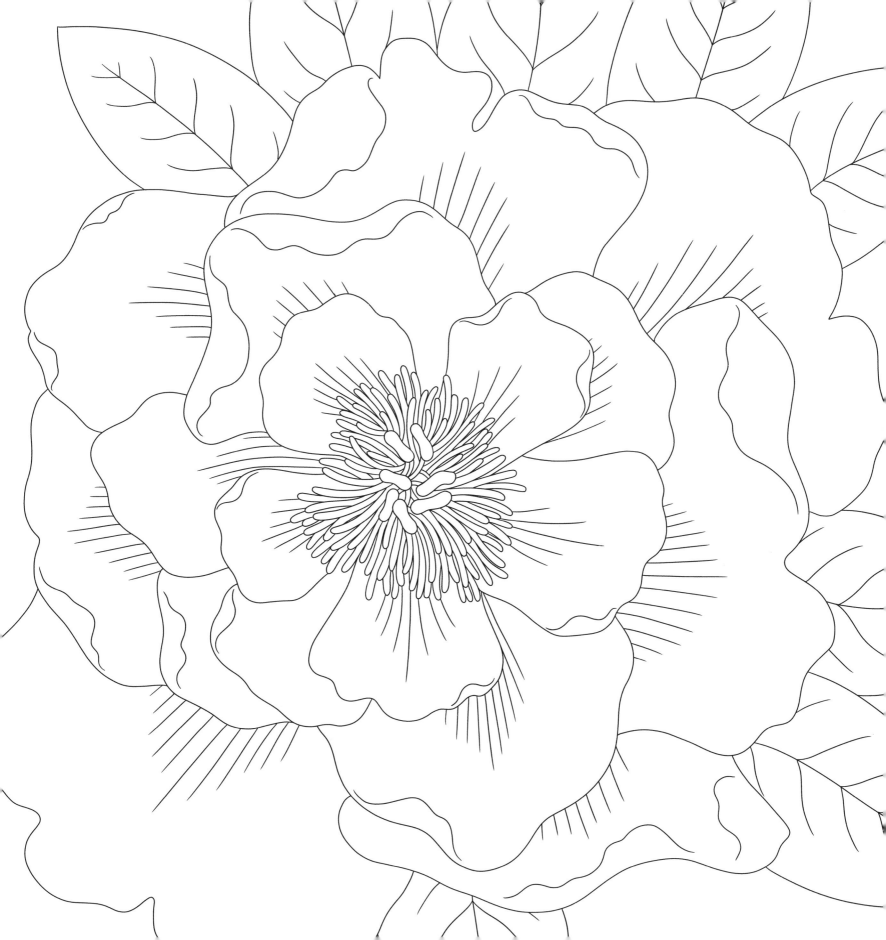

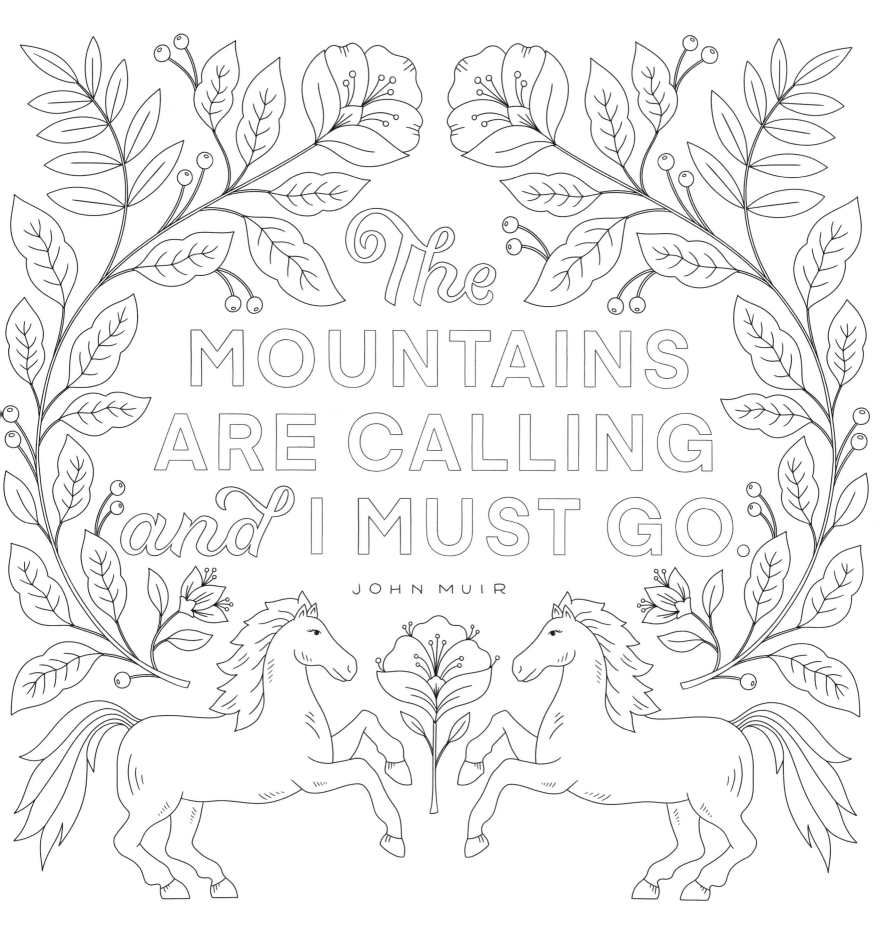

The MOUNTAINS ARE CALLING and I MUST GO.

JOHN MUIR

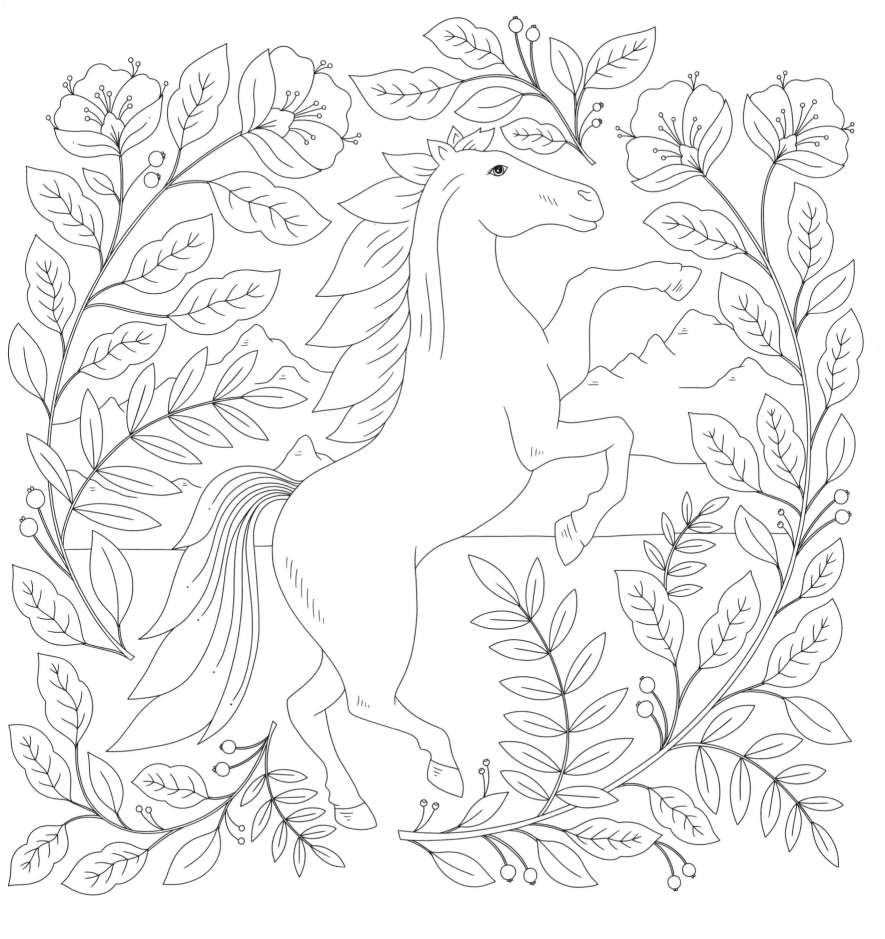

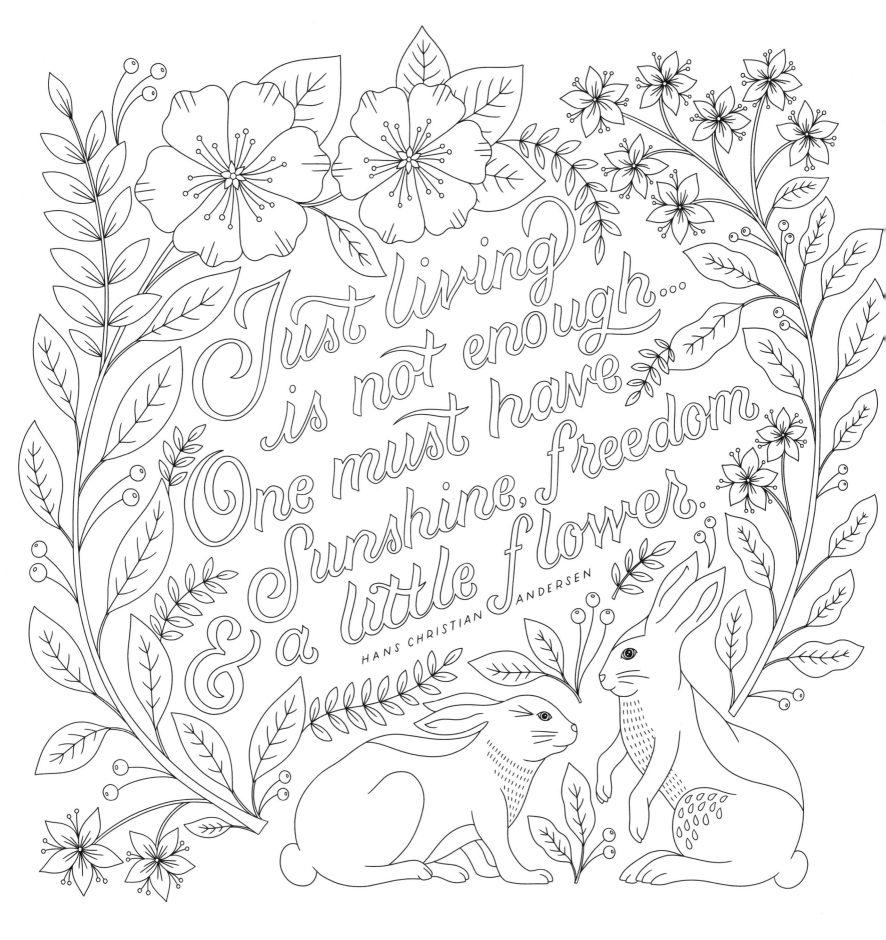

Just living is not enough... One must have Sunshine, freedom & a little flower.

HANS CHRISTIAN ANDERSEN

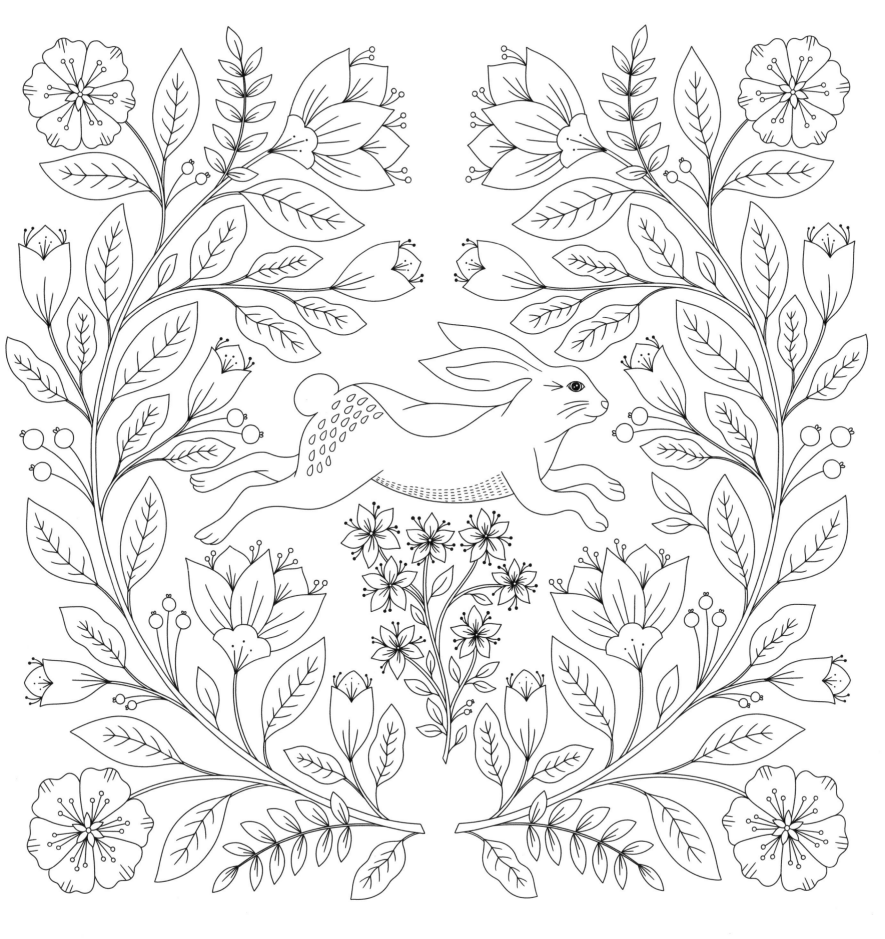

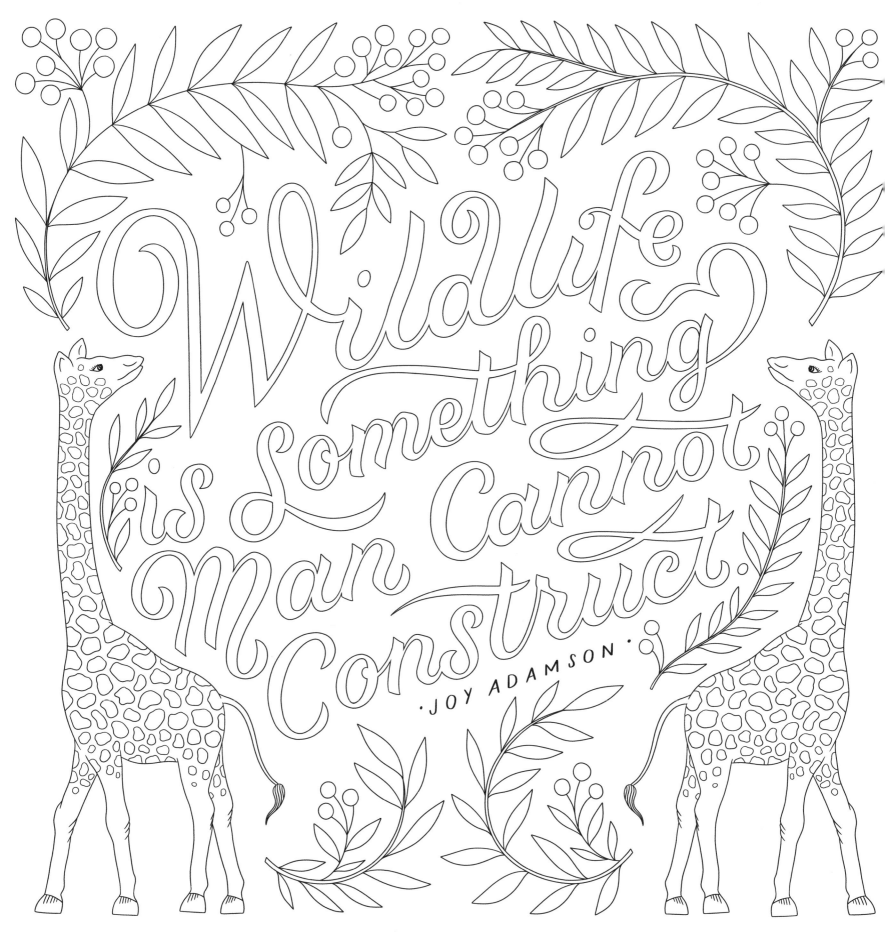

Wildlife is Something is Something Man Cannot Construct.

·JOY ADAMSON·

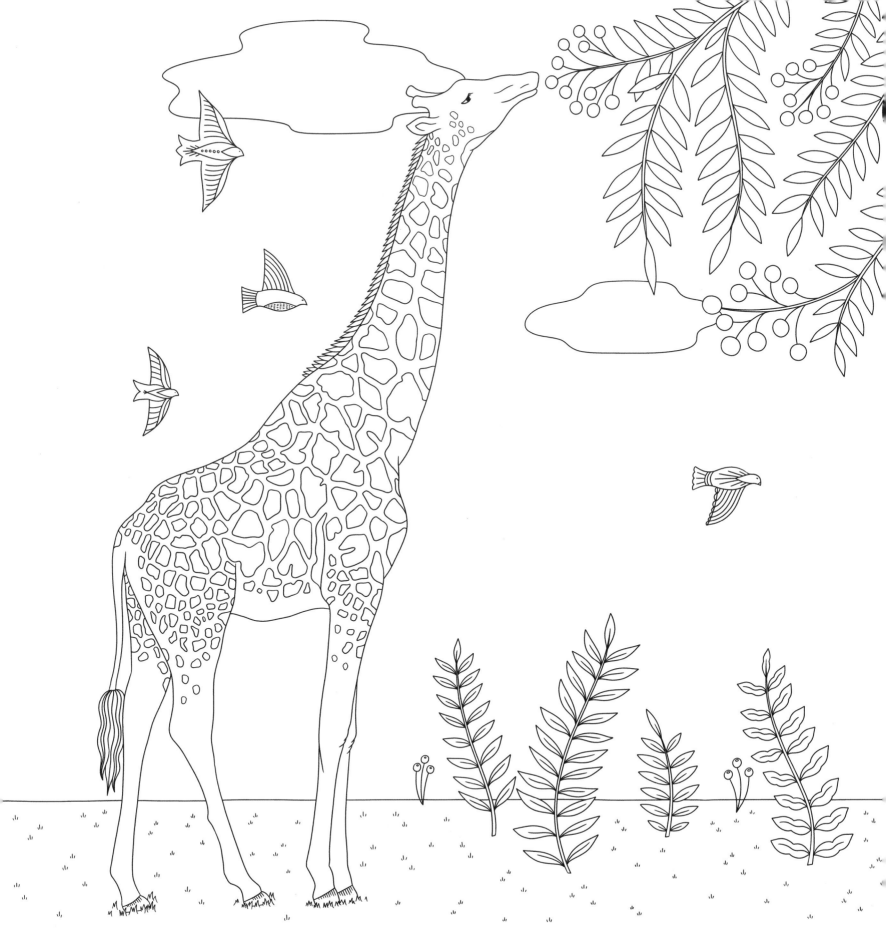

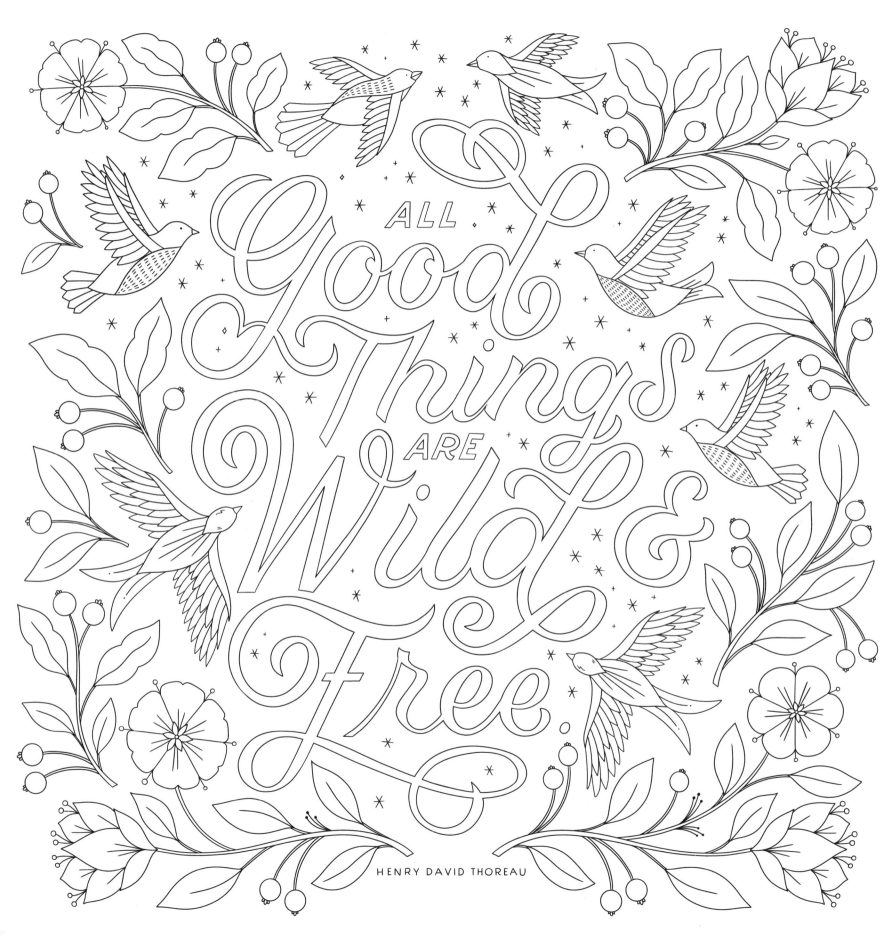

ALL Good Things ARE Wild & Free

HENRY DAVID THOREAU

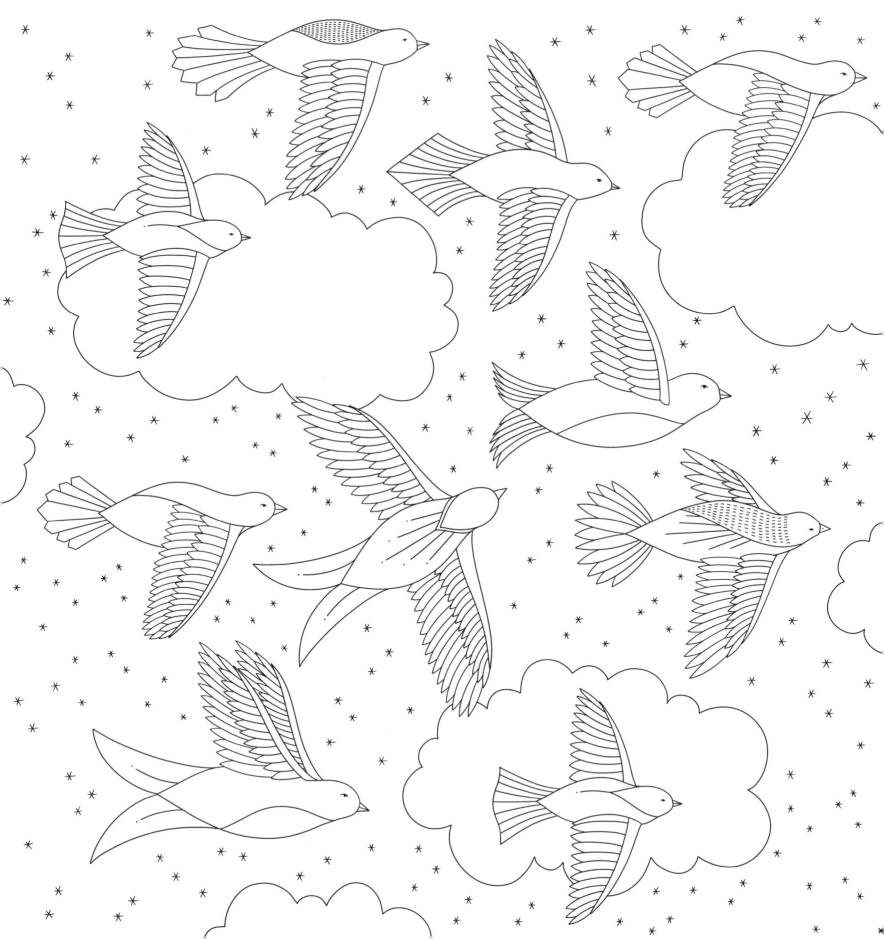

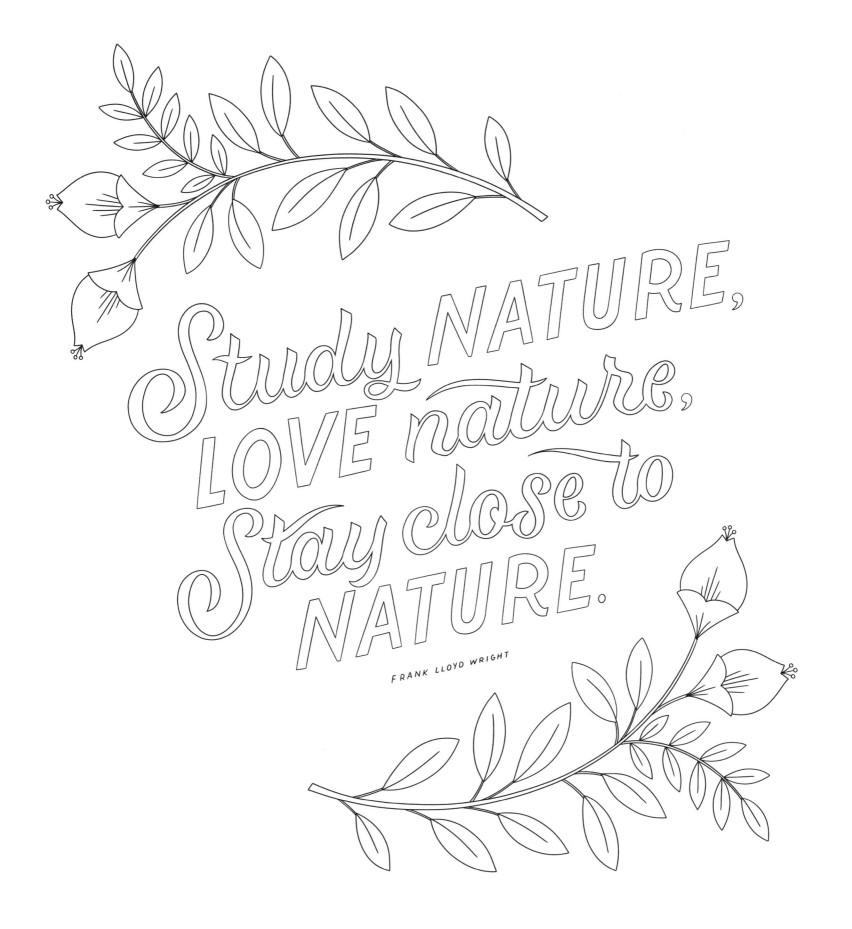

Study NATURE,
LOVE nature,
Stay close to NATURE.

FRANK LLOYD WRIGHT

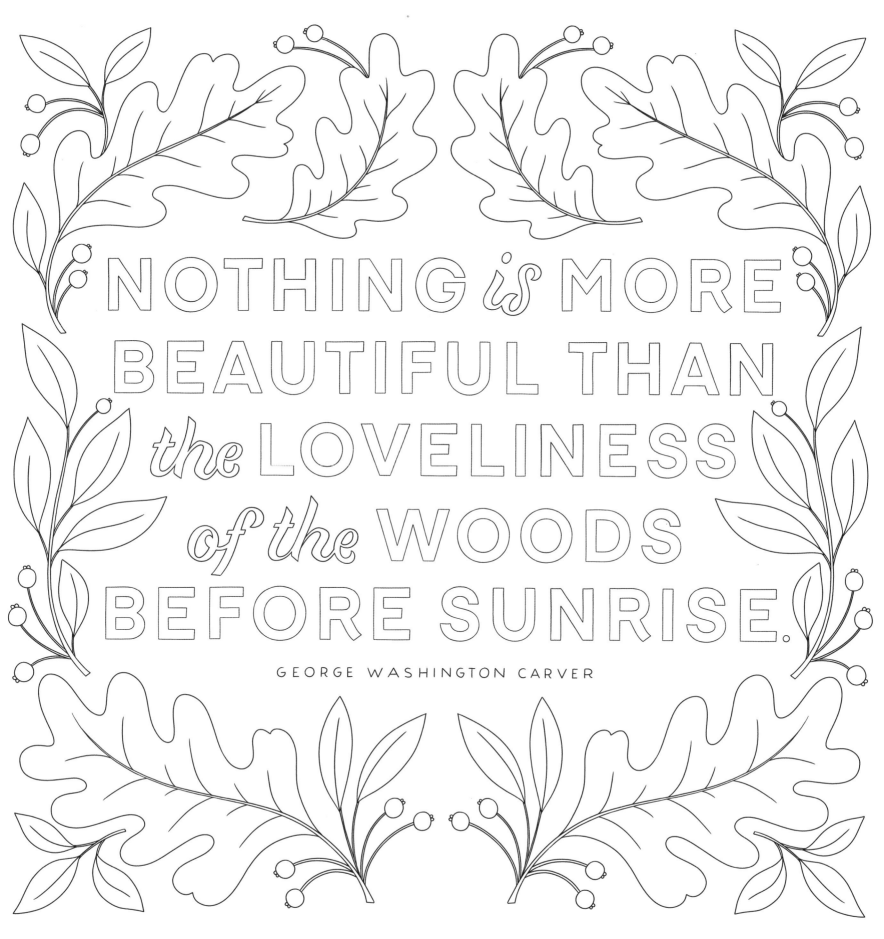

NOTHING *is* MORE BEAUTIFUL THAN *the* LOVELINESS *of the* WOODS BEFORE SUNRISE.

GEORGE WASHINGTON CARVER

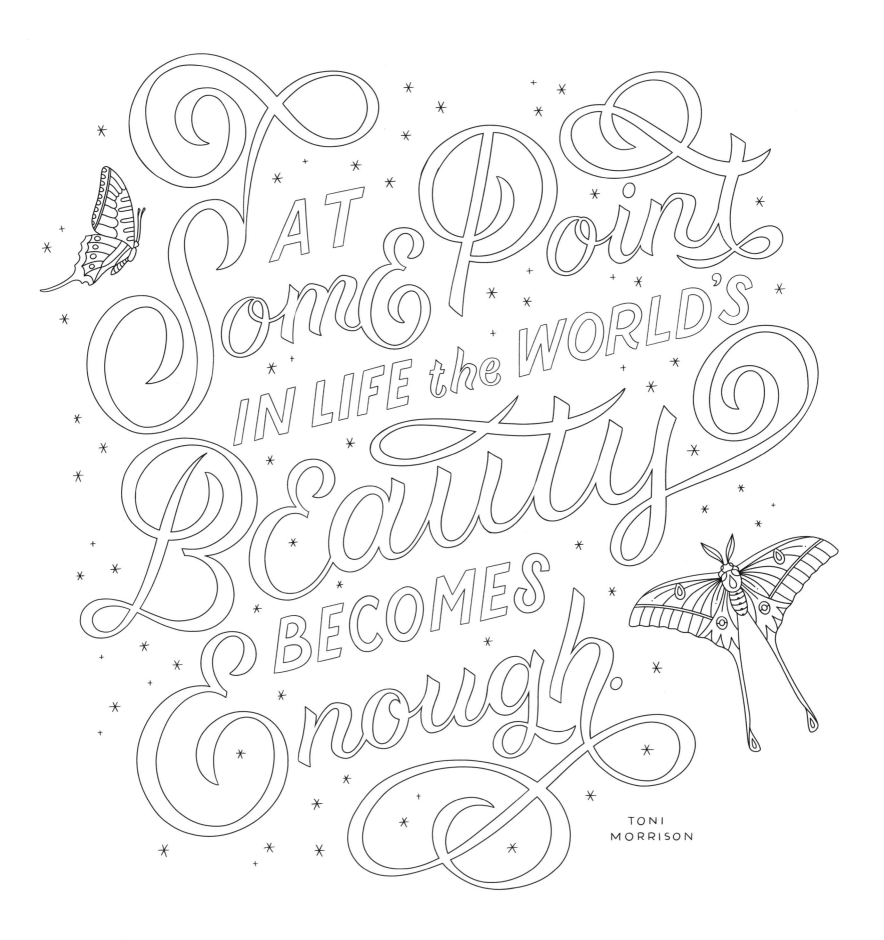

At Some Point IN LIFE the WORLD'S Beauty BECOMES Enough.

TONI MORRISON

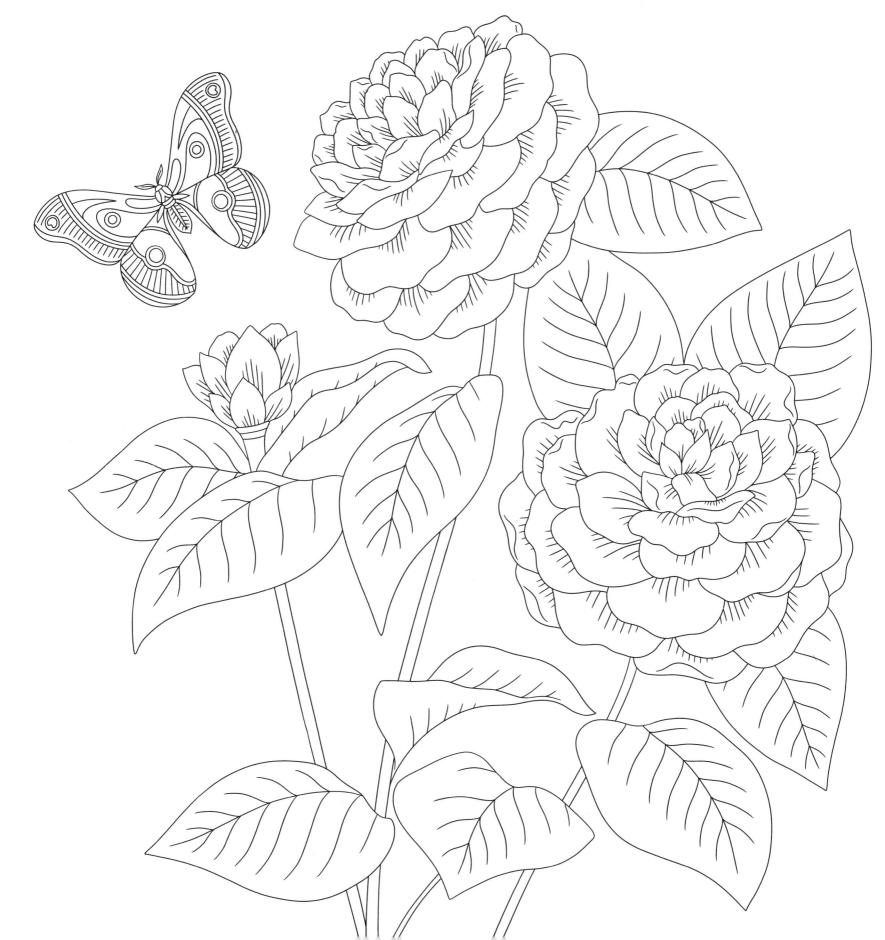

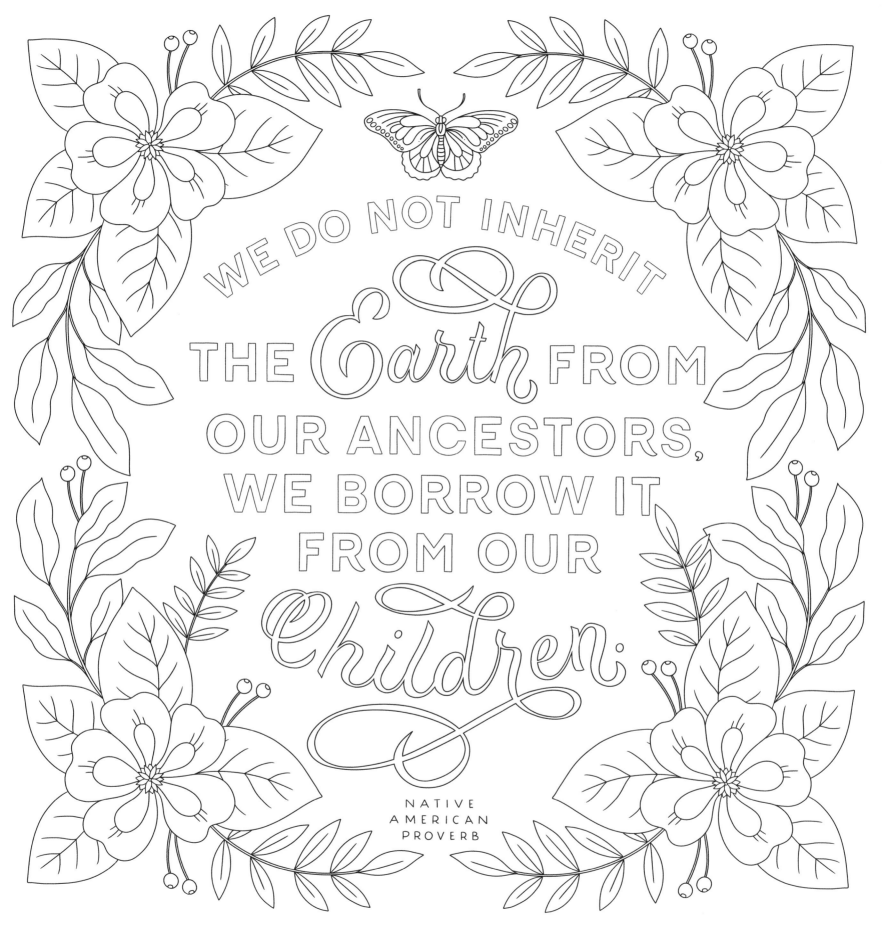

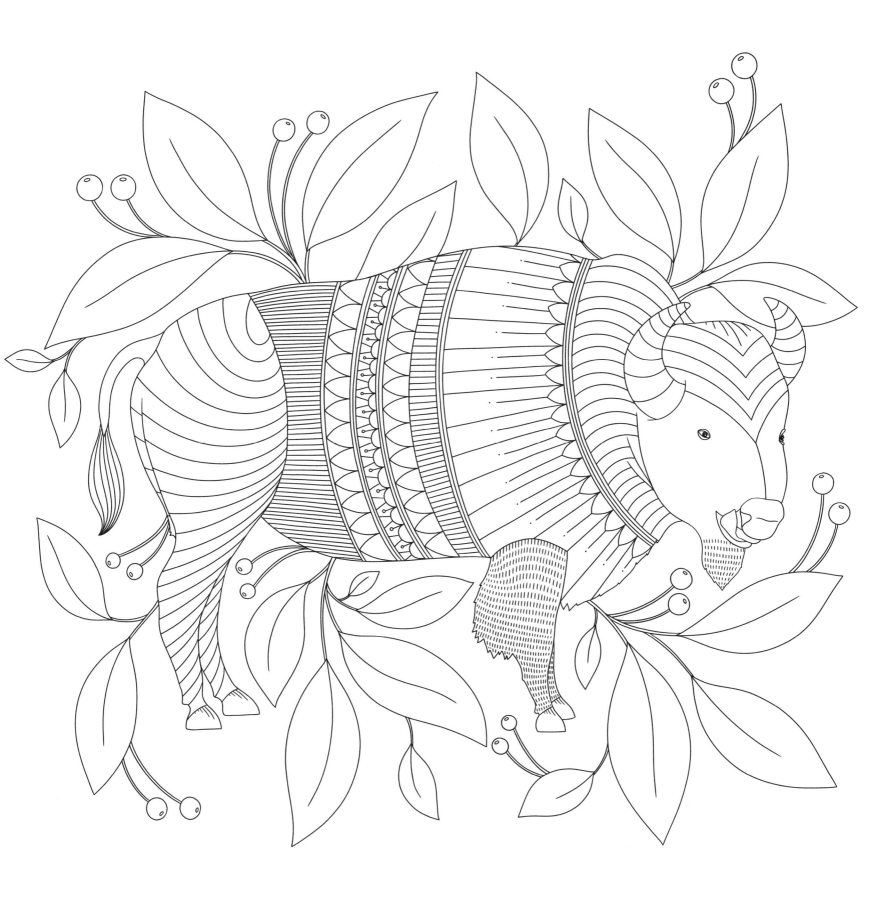

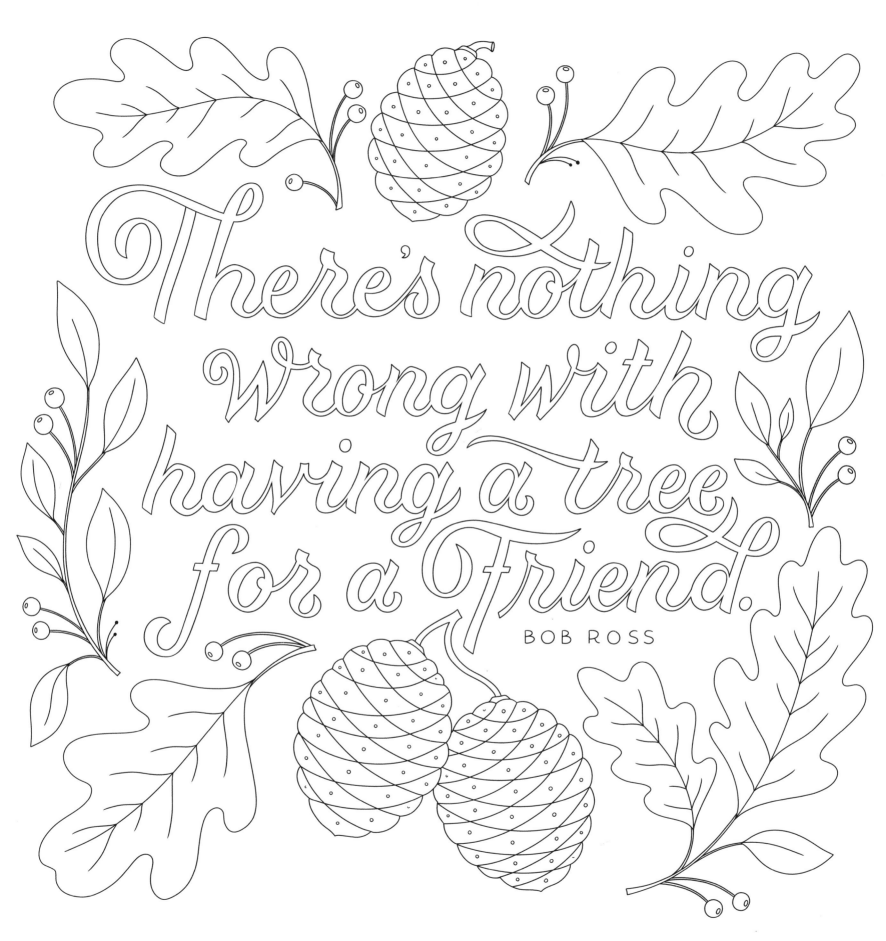

There's nothing wrong with having a tree for a Friend.

BOB ROSS

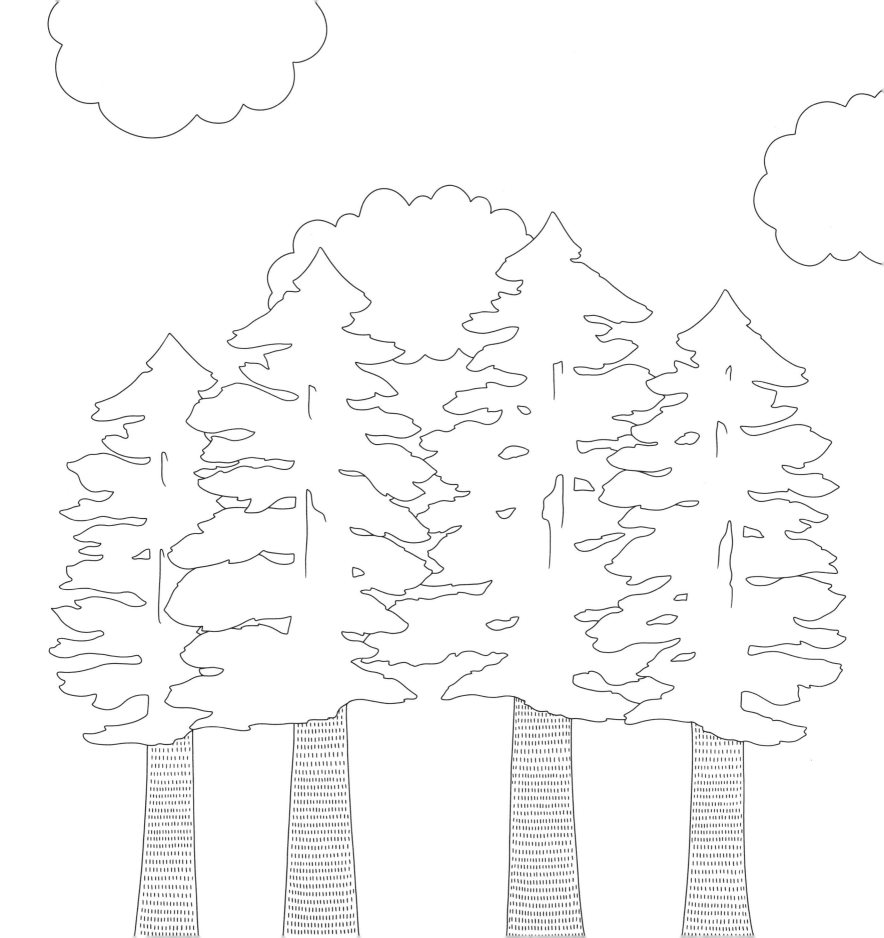

WHAT WE CALL the HIGHEST and the LOWEST in NATURE are Equally Perfect.

BEATRIX POTTER

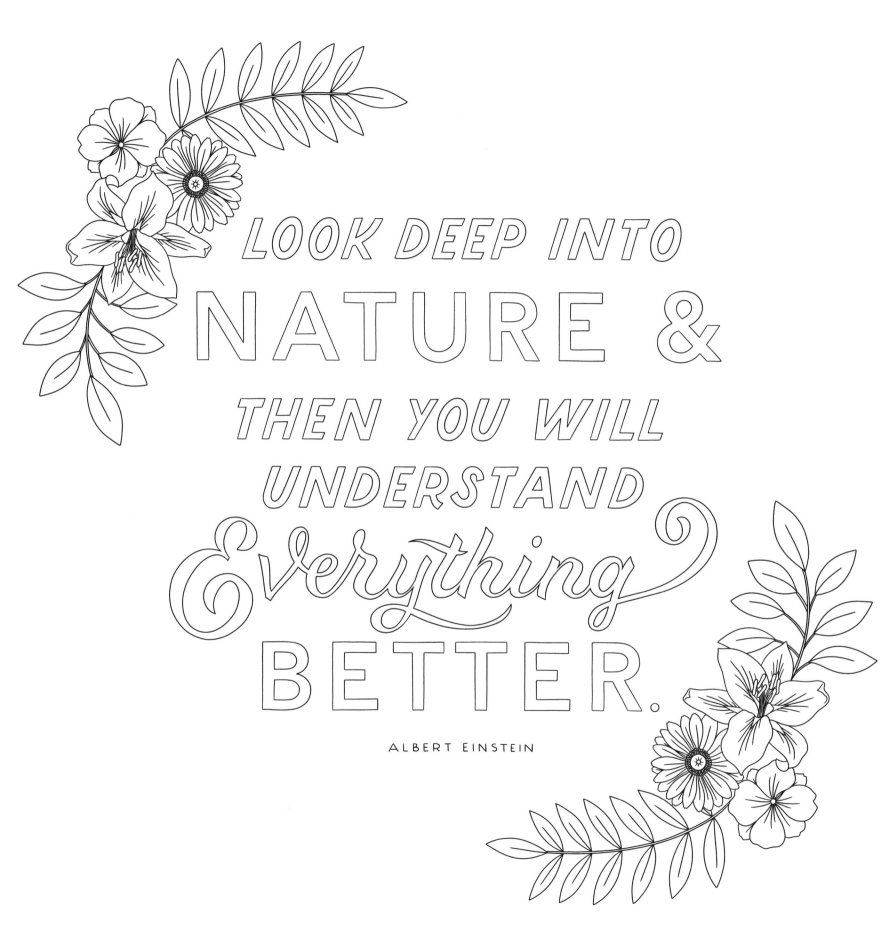

LOOK DEEP INTO NATURE & THEN YOU WILL UNDERSTAND *Everything* BETTER.

ALBERT EINSTEIN

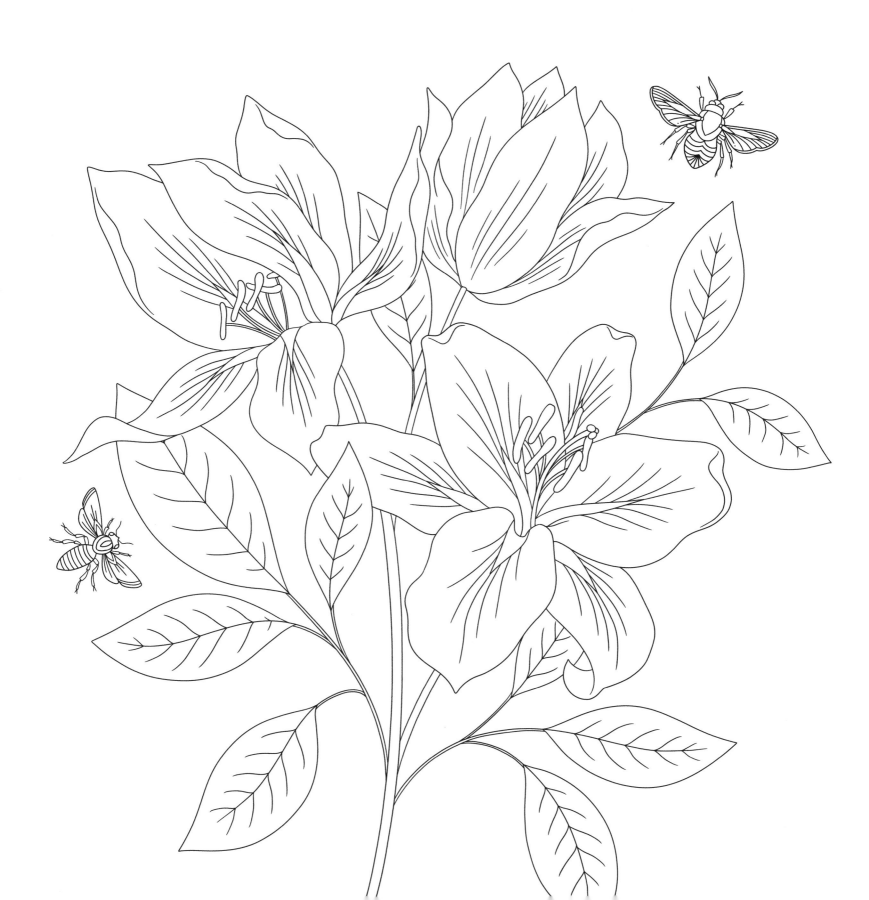

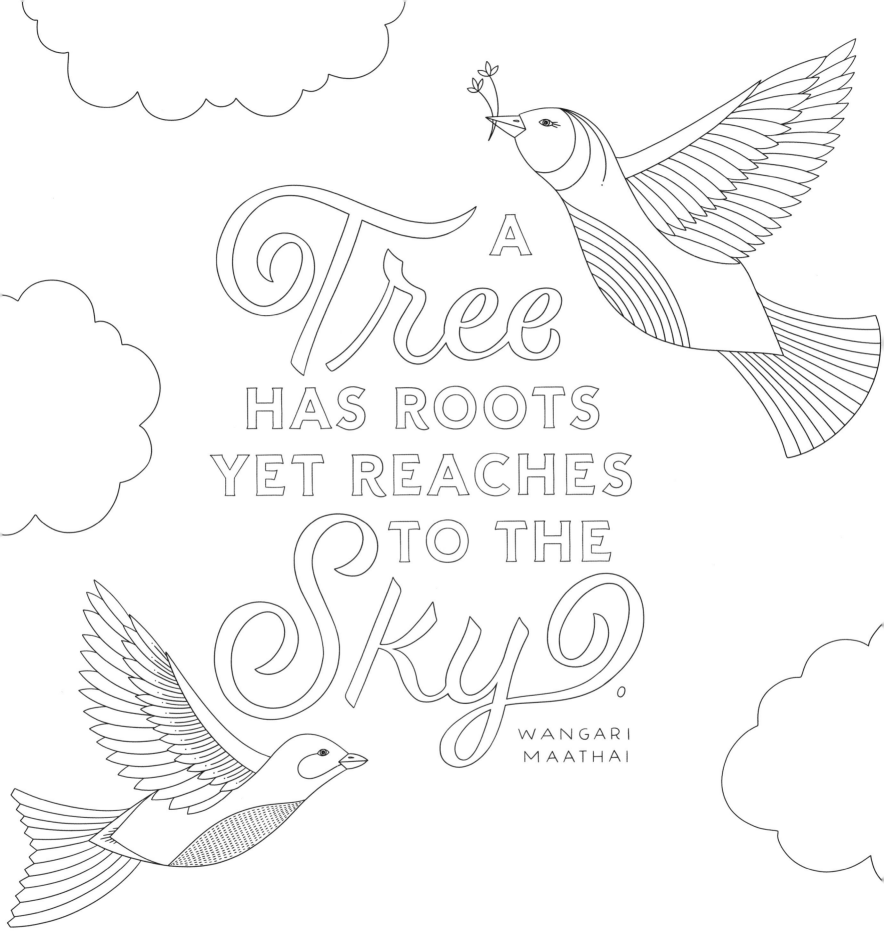

A Tree HAS ROOTS YET REACHES TO THE Sky.

WANGARI MAATHAI

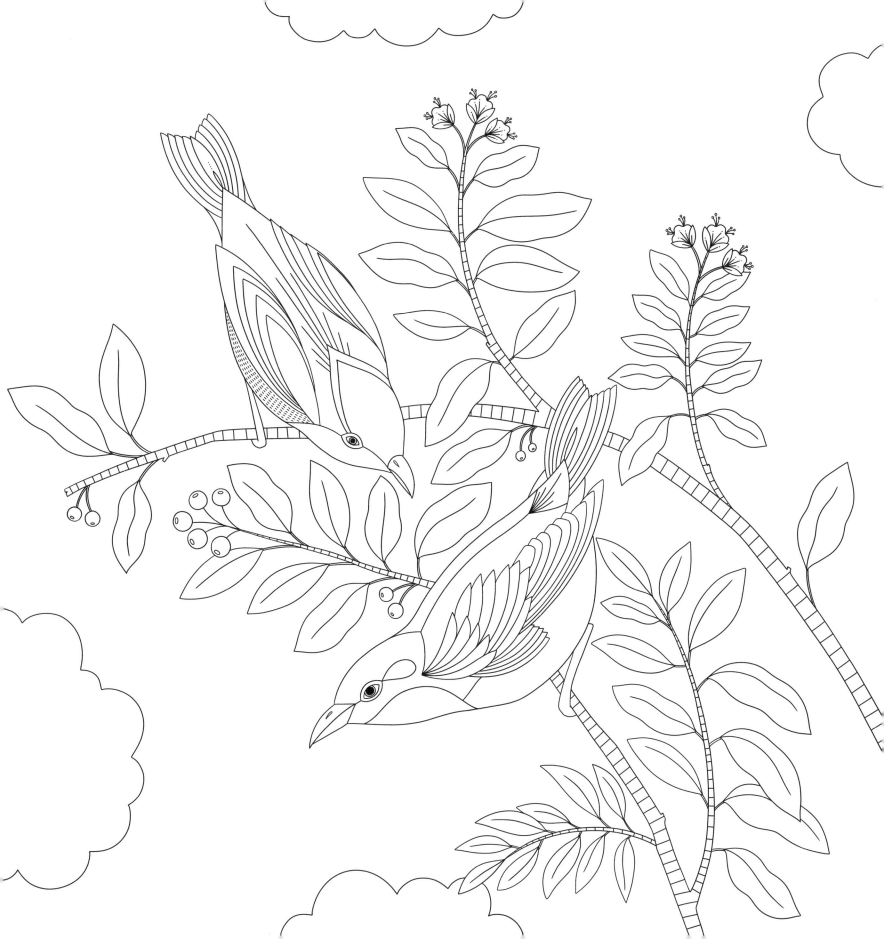

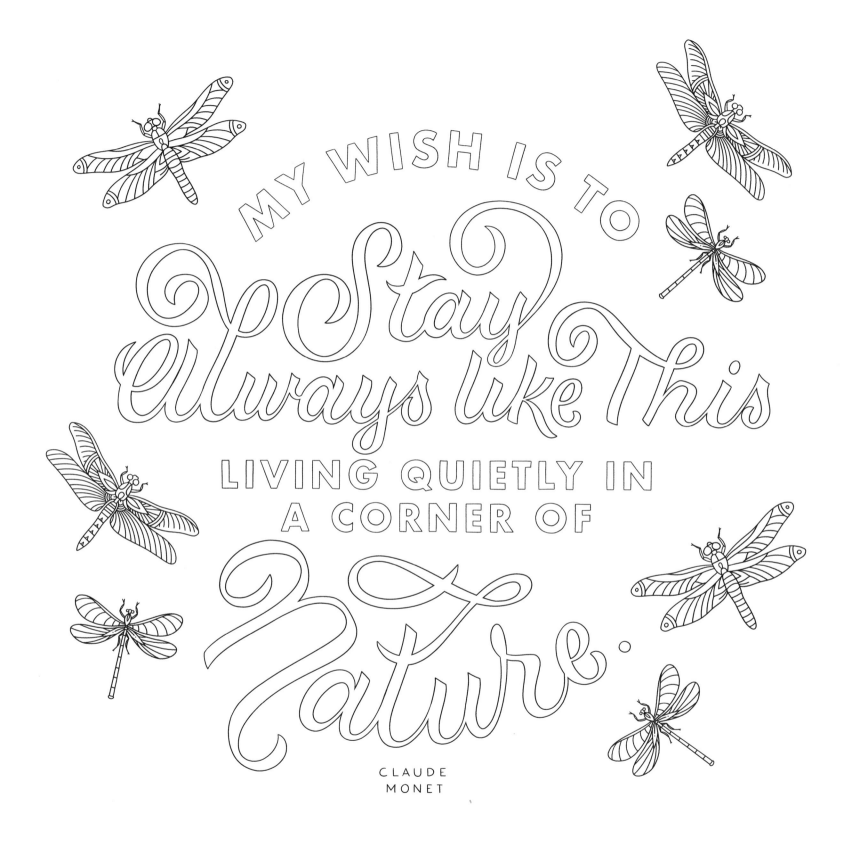

MY WISH IS TO
Stay
Always like This
LIVING QUIETLY IN
A CORNER OF
Nature.

CLAUDE
MONET

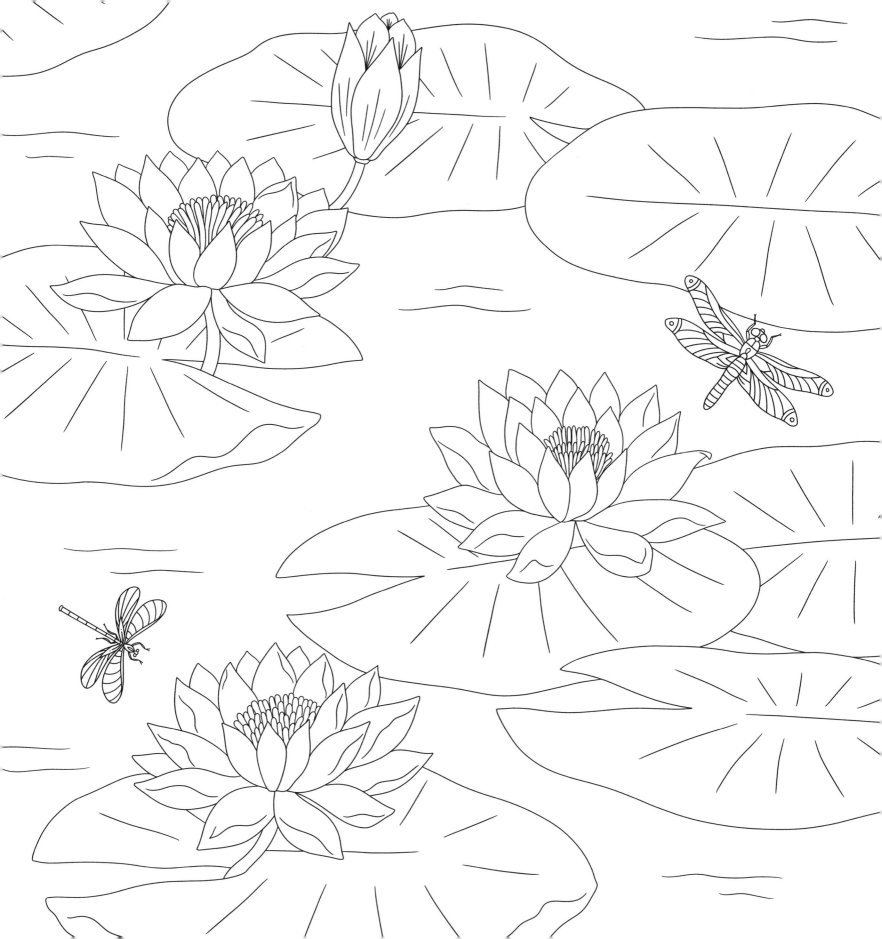

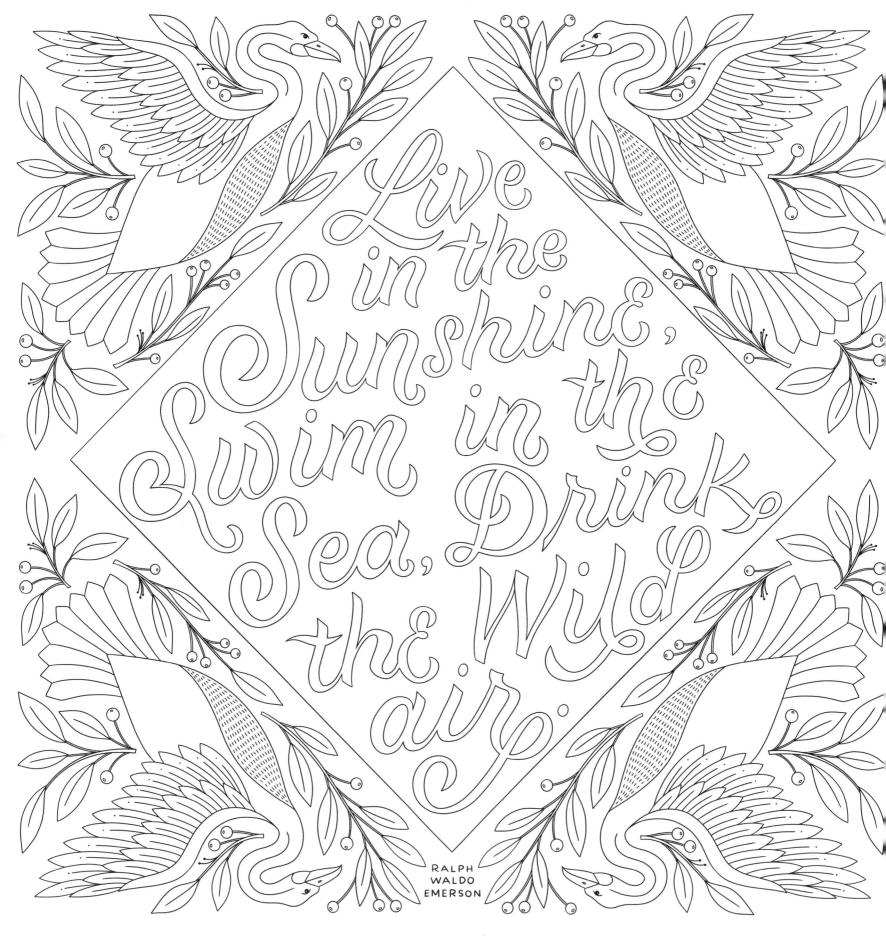

Live in the Sunshine, Swim in the Sea, Drink in the Wild air.

RALPH WALDO EMERSON

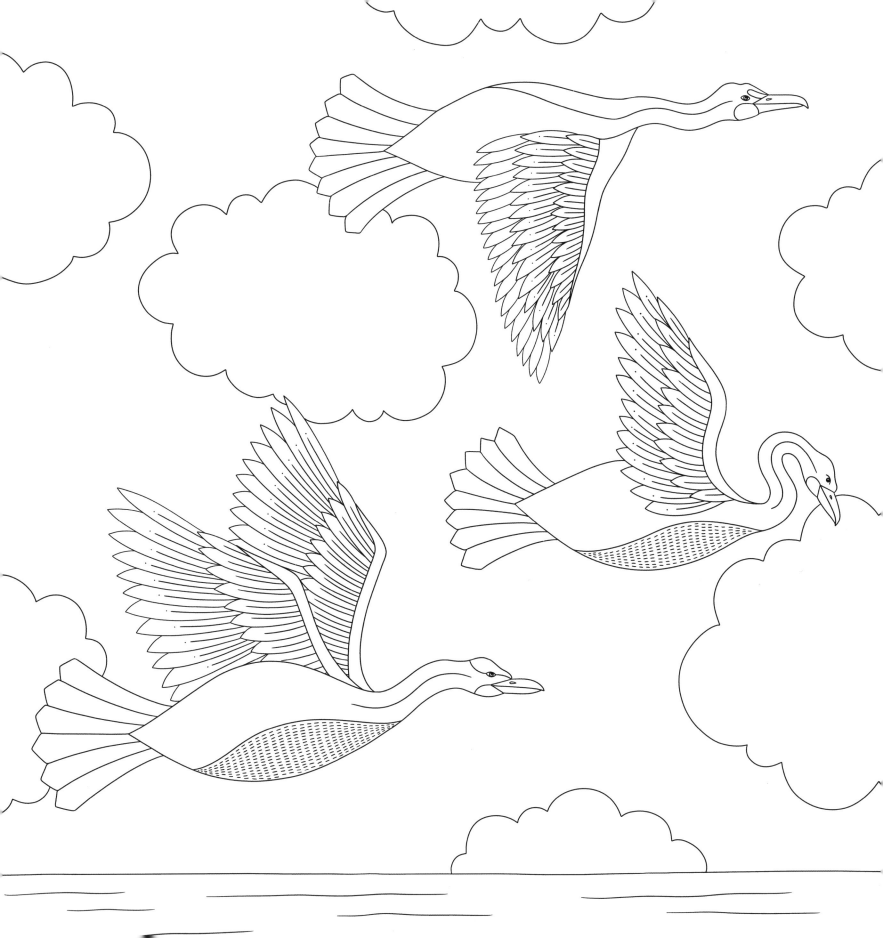

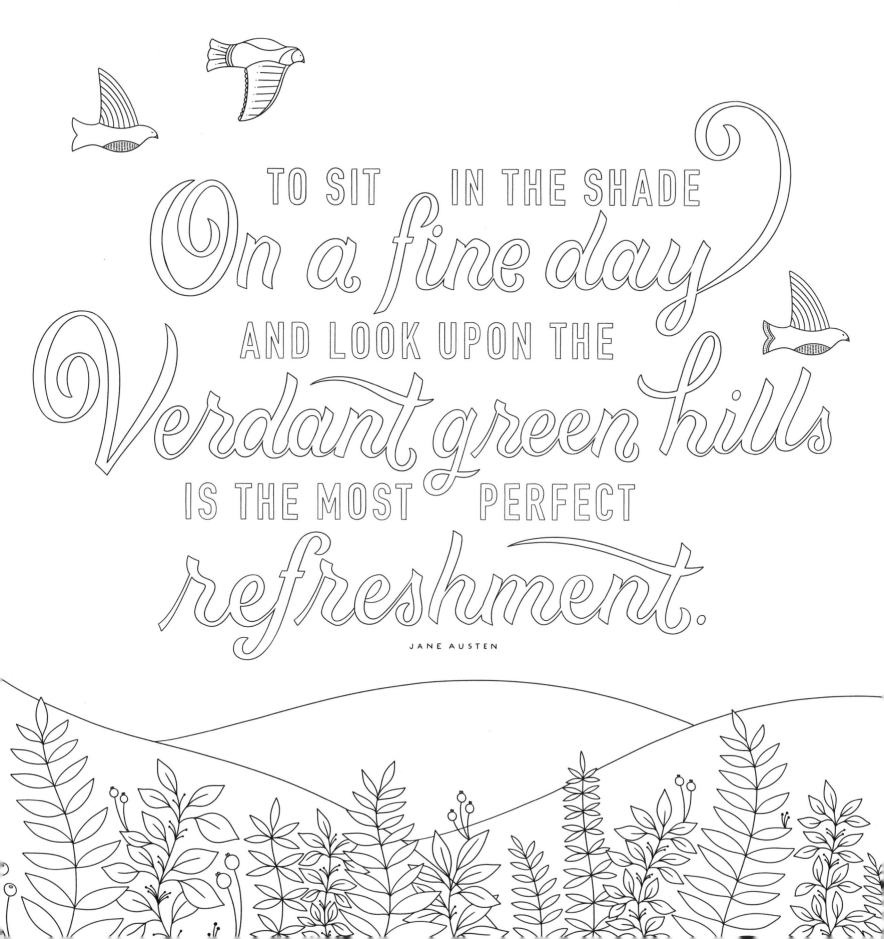

TO SIT IN THE SHADE
On a fine day
AND LOOK UPON THE
Verdant green hills
IS THE MOST PERFECT
refreshment.

JANE AUSTEN

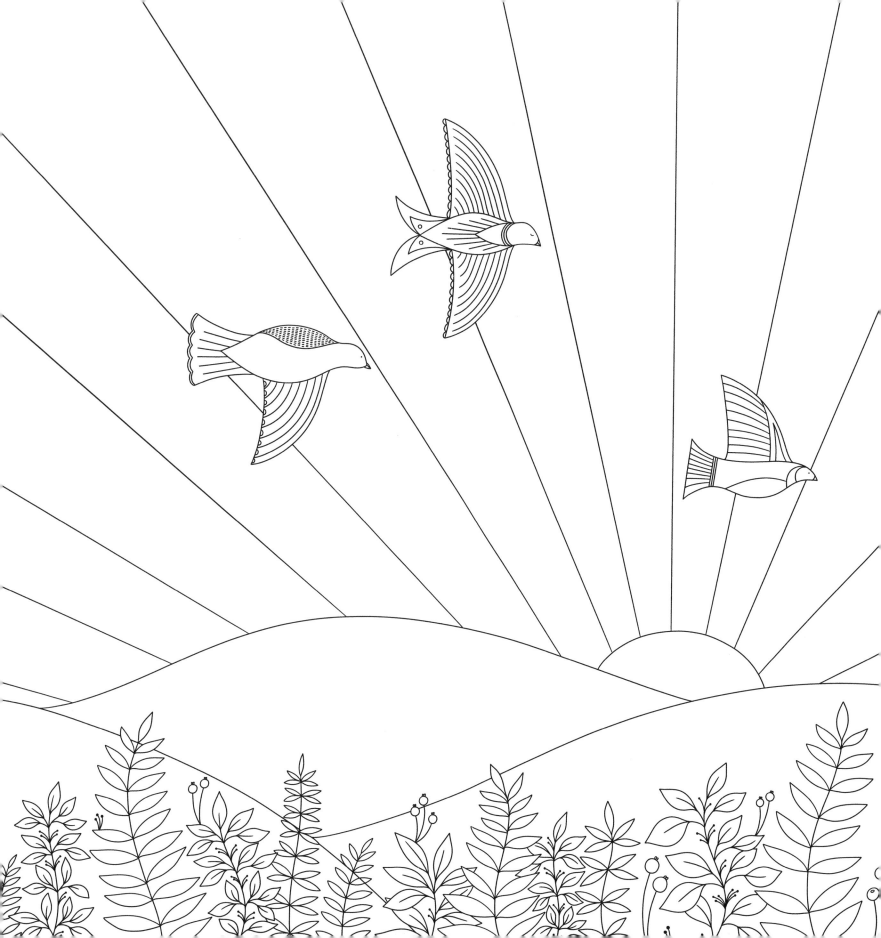

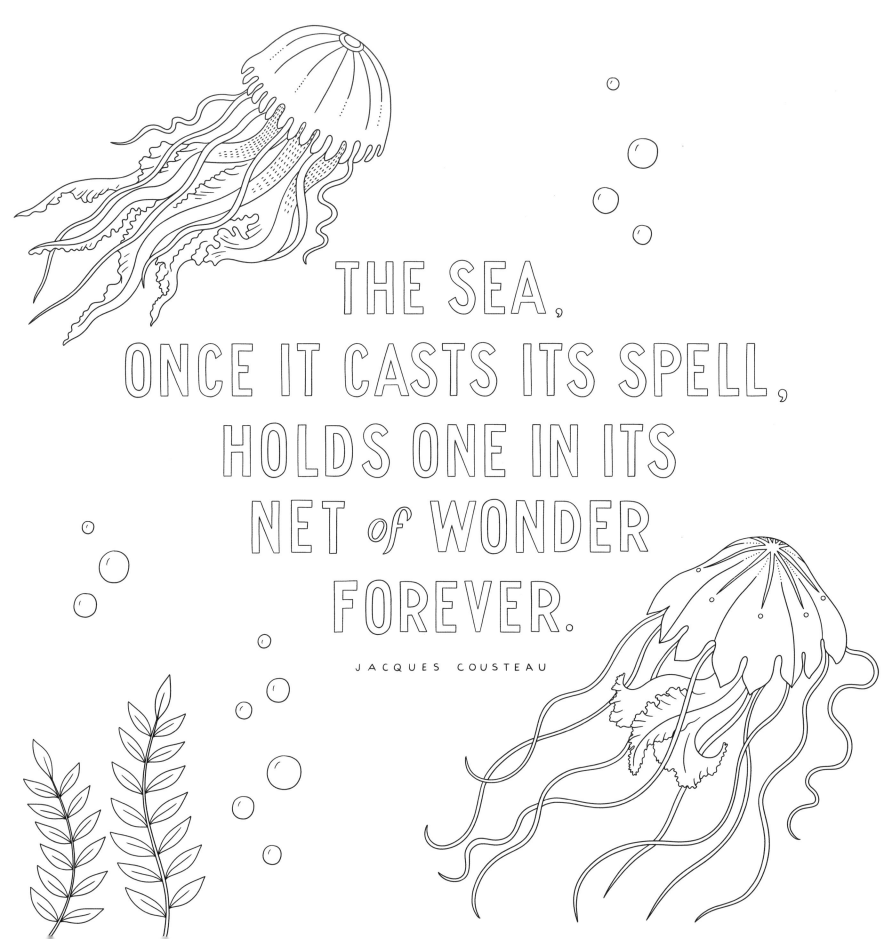

THE SEA,
ONCE IT CASTS ITS SPELL,
HOLDS ONE IN ITS
NET *of* WONDER
FOREVER.

JACQUES COUSTEAU

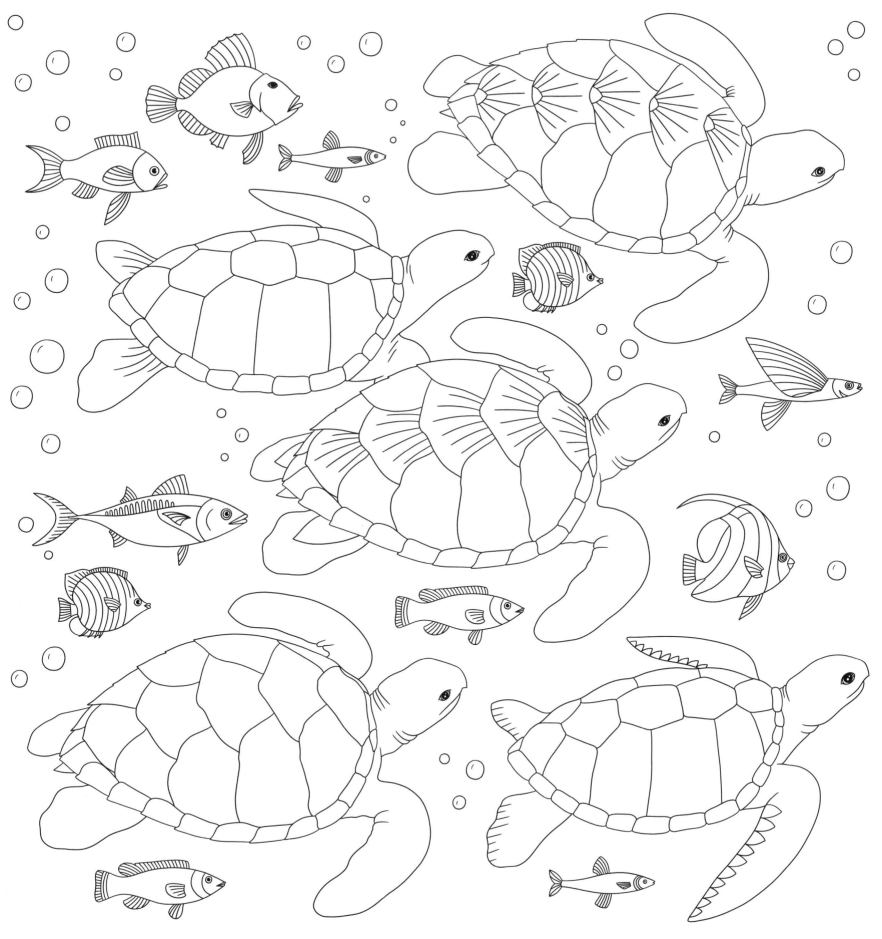

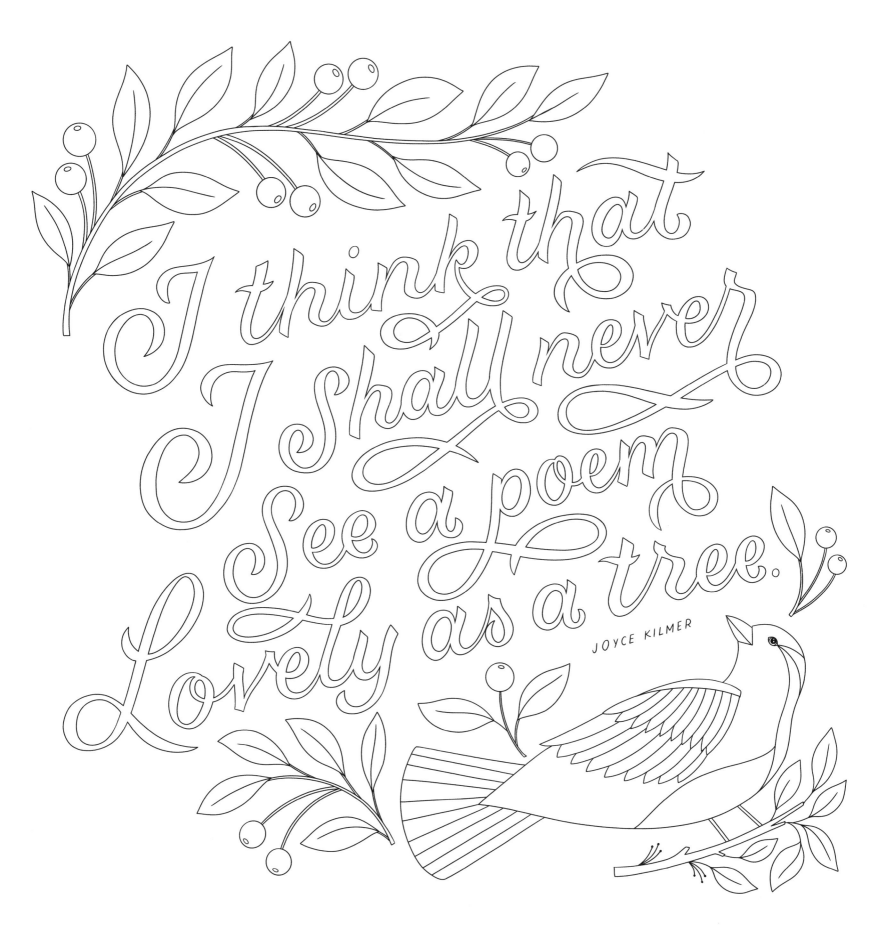

I think that
I shall never
See a poem
Lovely as a tree.

JOYCE KILMER

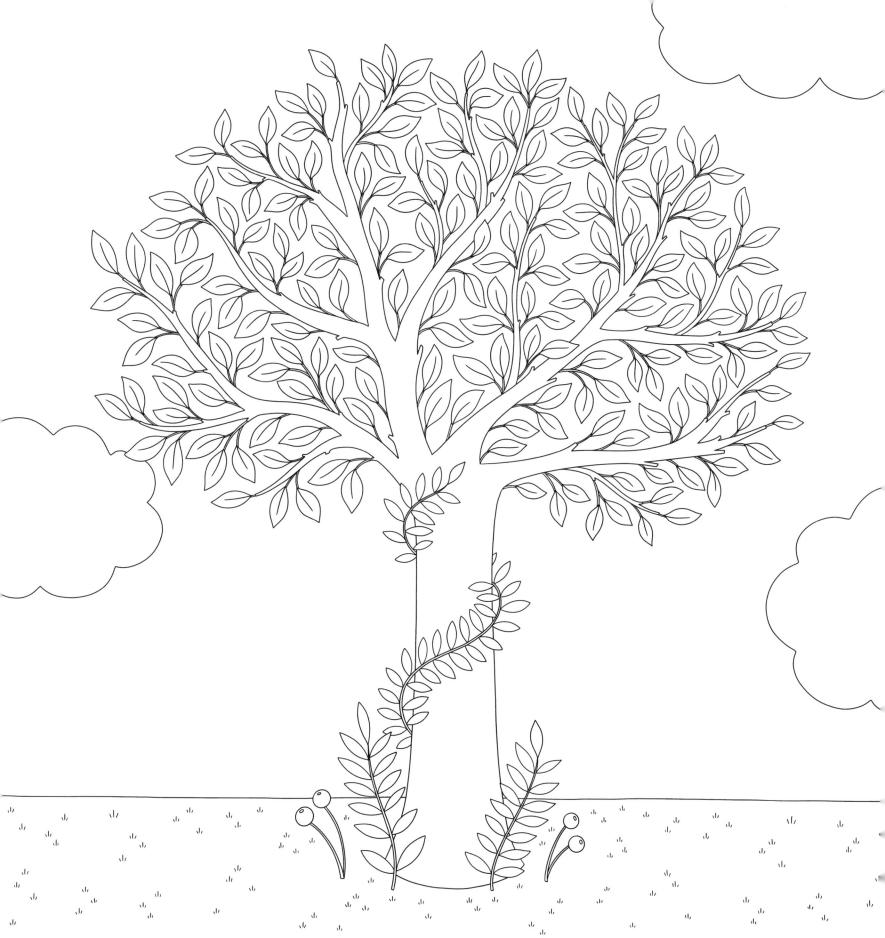

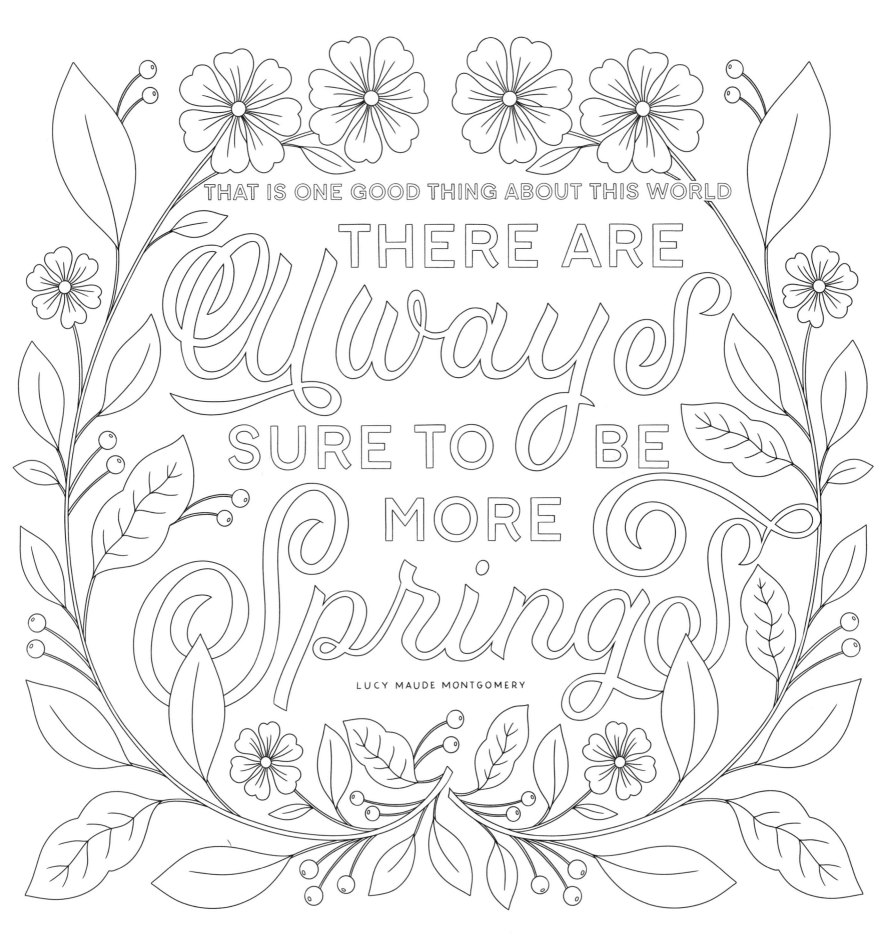

THAT IS ONE GOOD THING ABOUT THIS WORLD

THERE ARE *Always* SURE TO *BE* MORE *Springs*

LUCY MAUDE MONTGOMERY

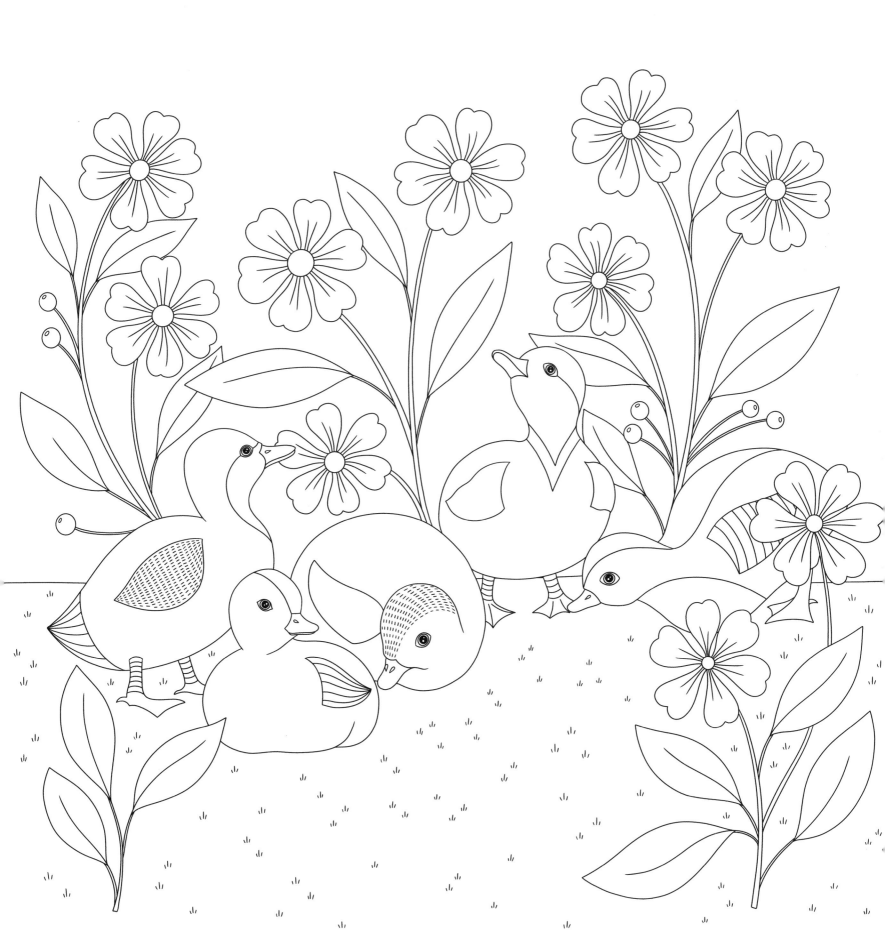

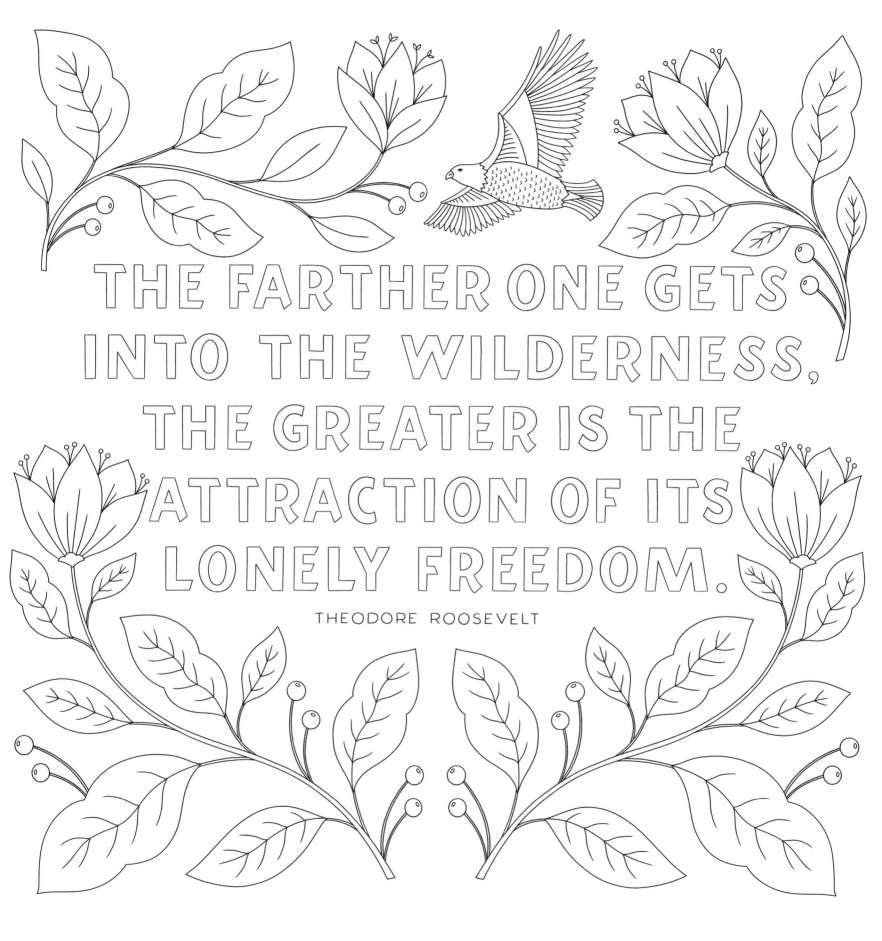

THE FARTHER ONE GETS INTO THE WILDERNESS, THE GREATER IS THE ATTRACTION OF ITS LONELY FREEDOM.

THEODORE ROOSEVELT

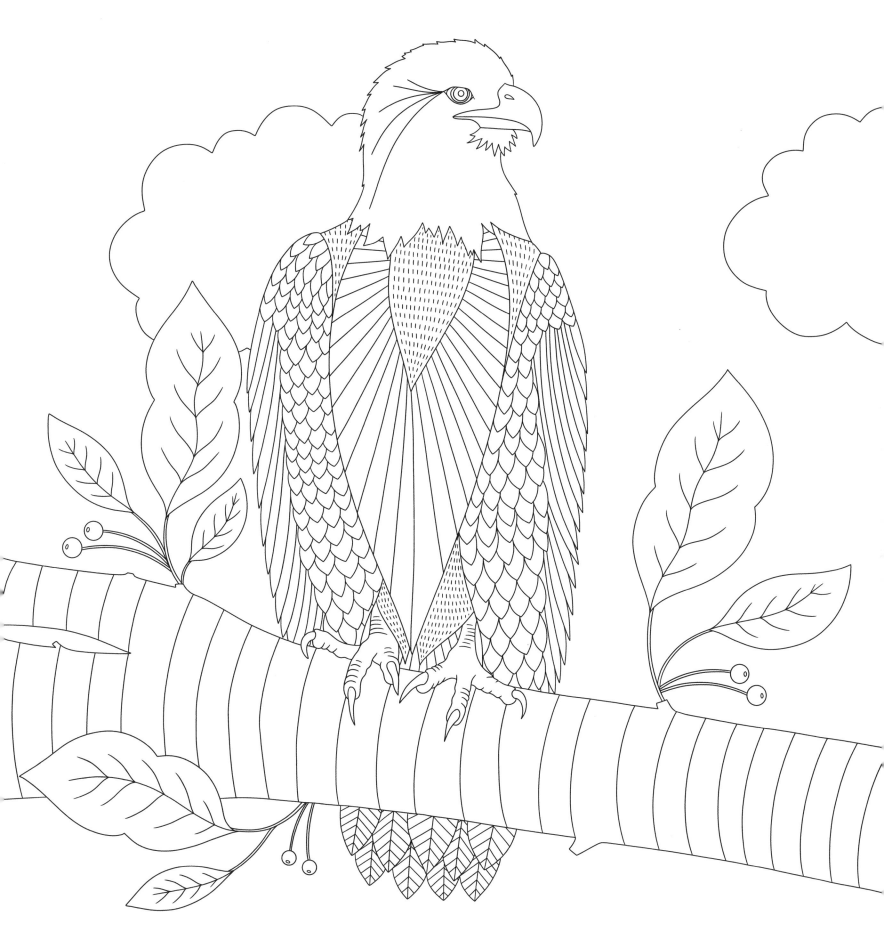

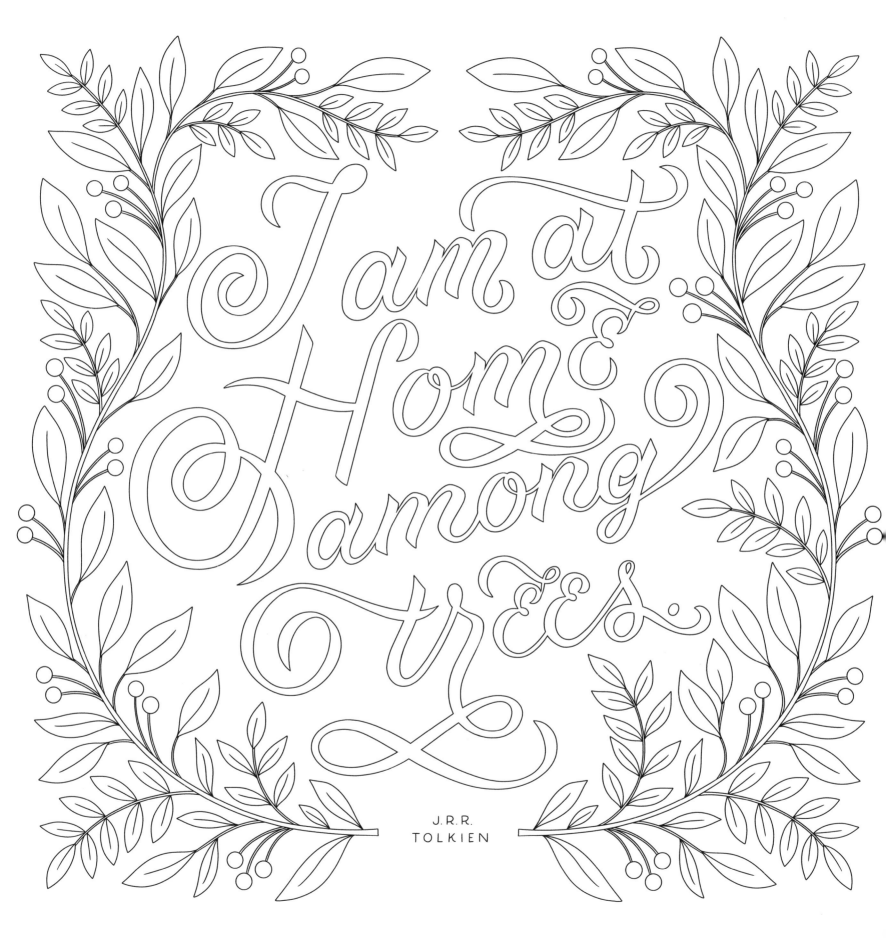

I am at Home among trees.

J. R. R.
TOLKIEN

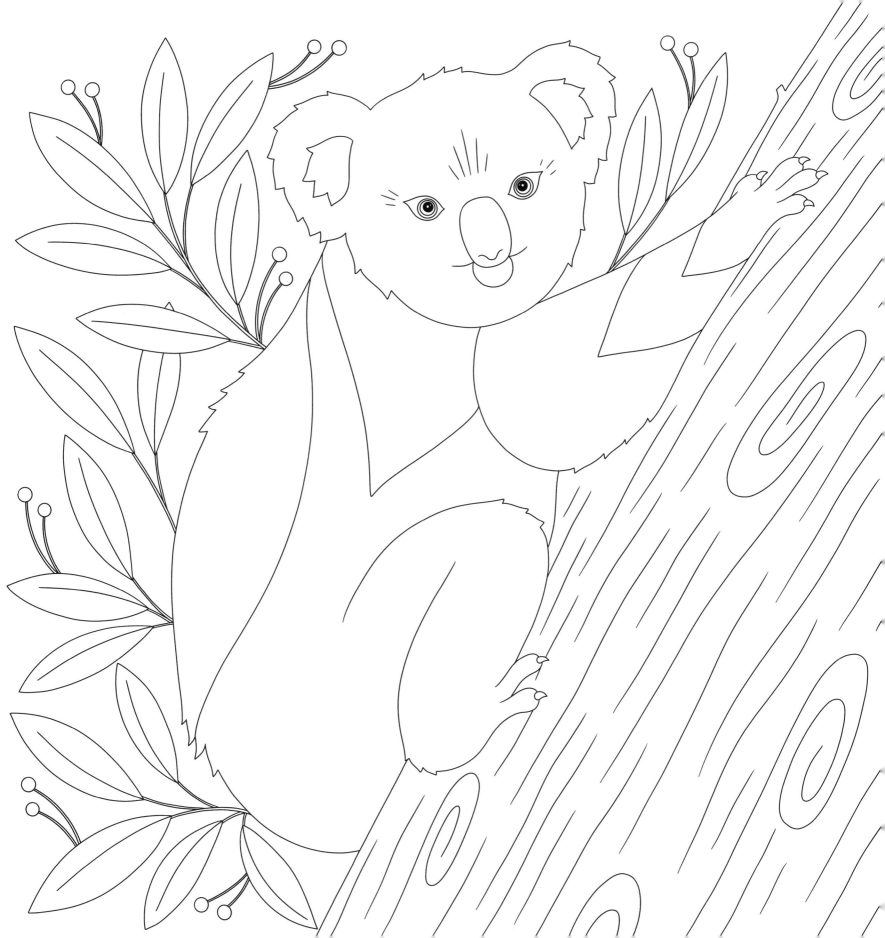

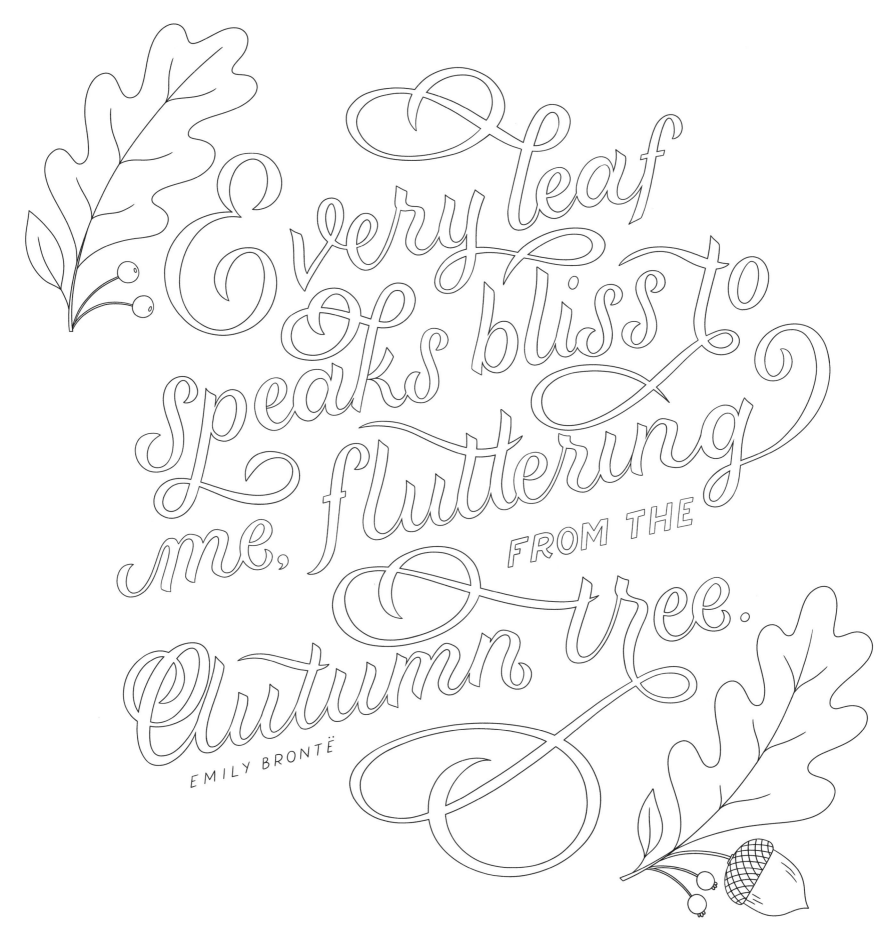

Every leaf speaks bliss to me, fluttering FROM THE Autumn tree.

EMILY BRONTË

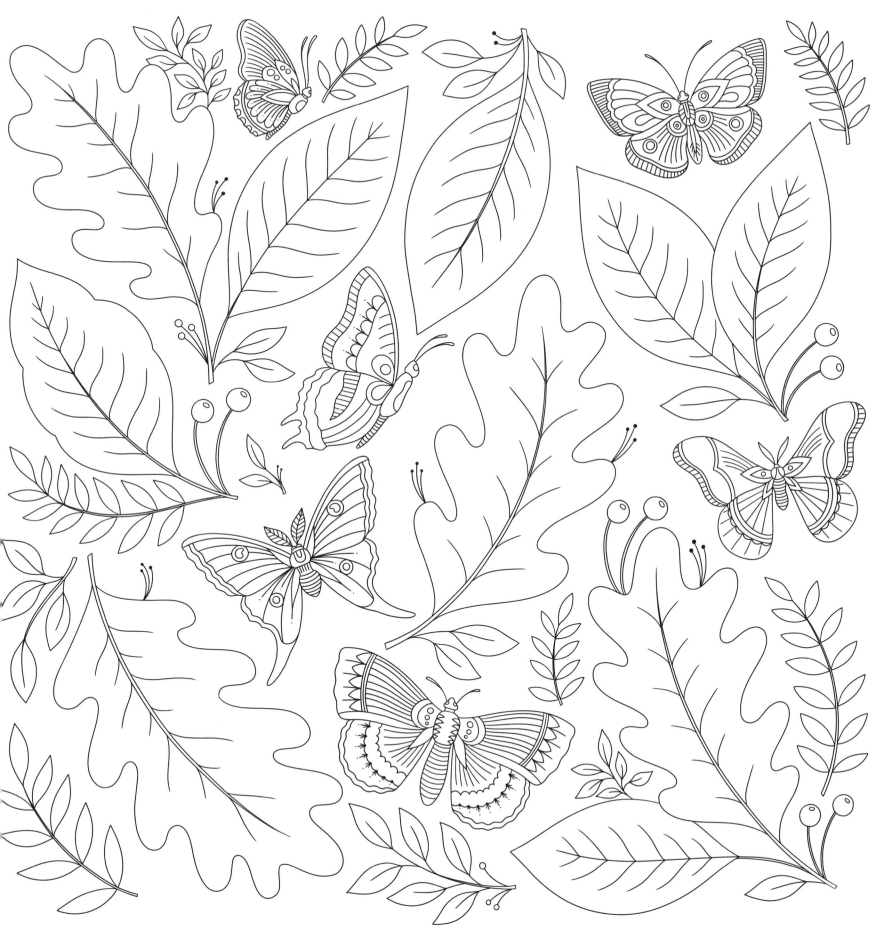

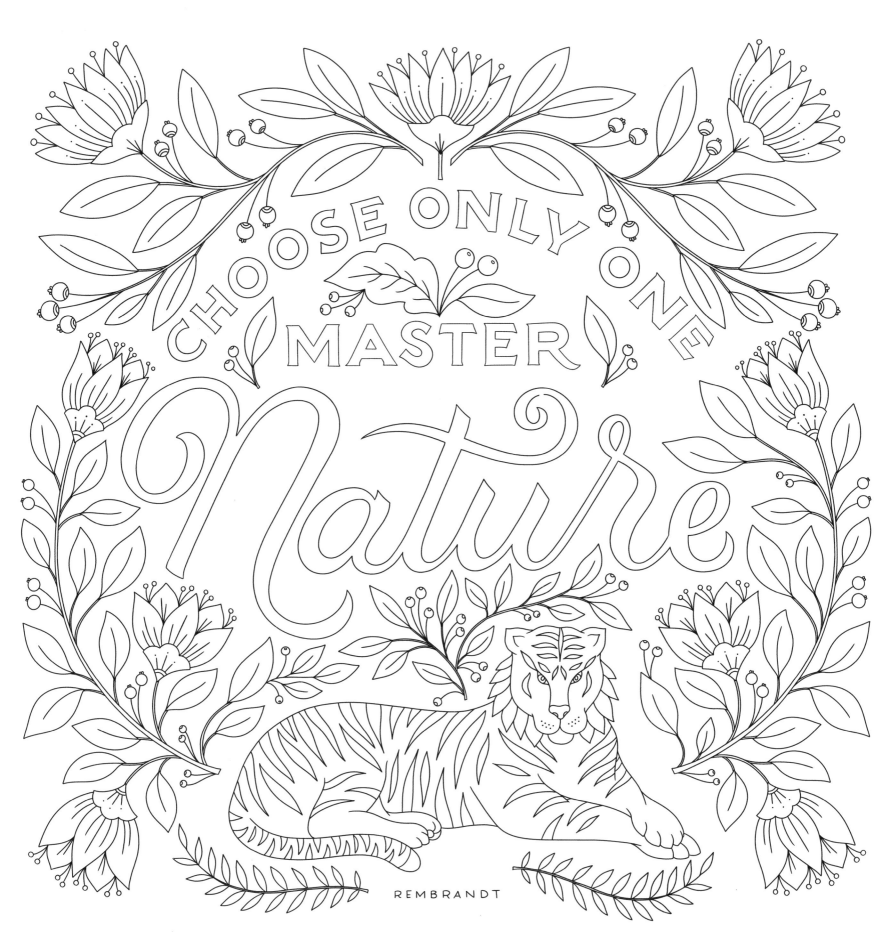

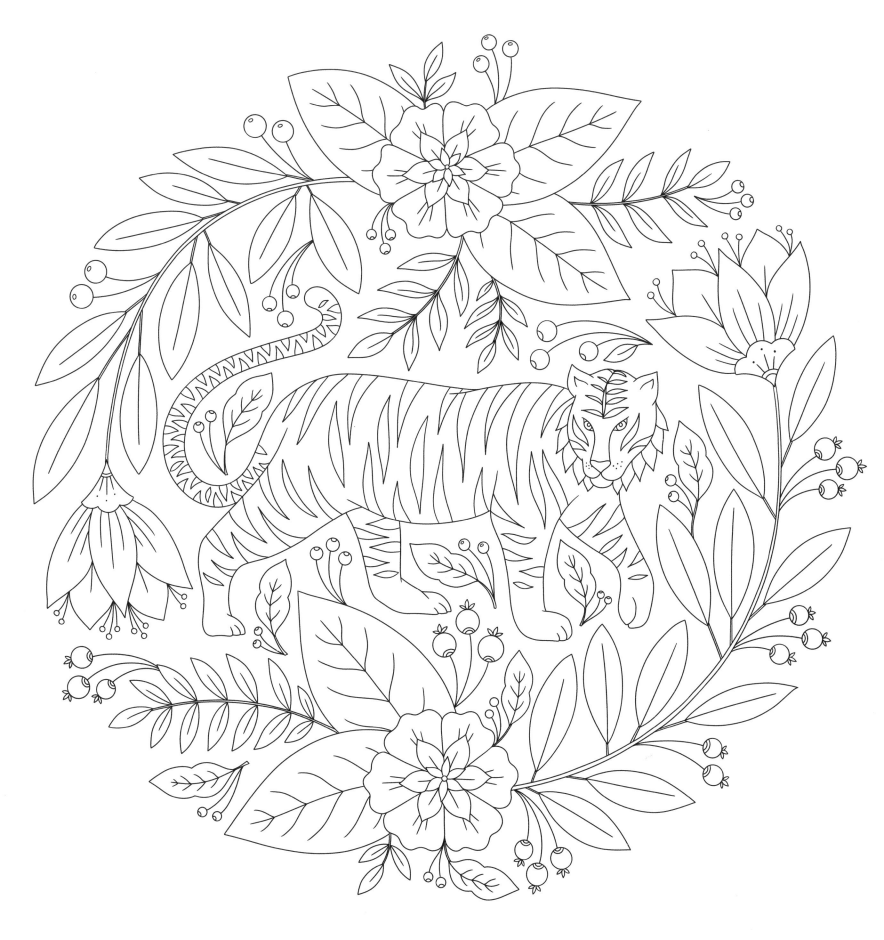

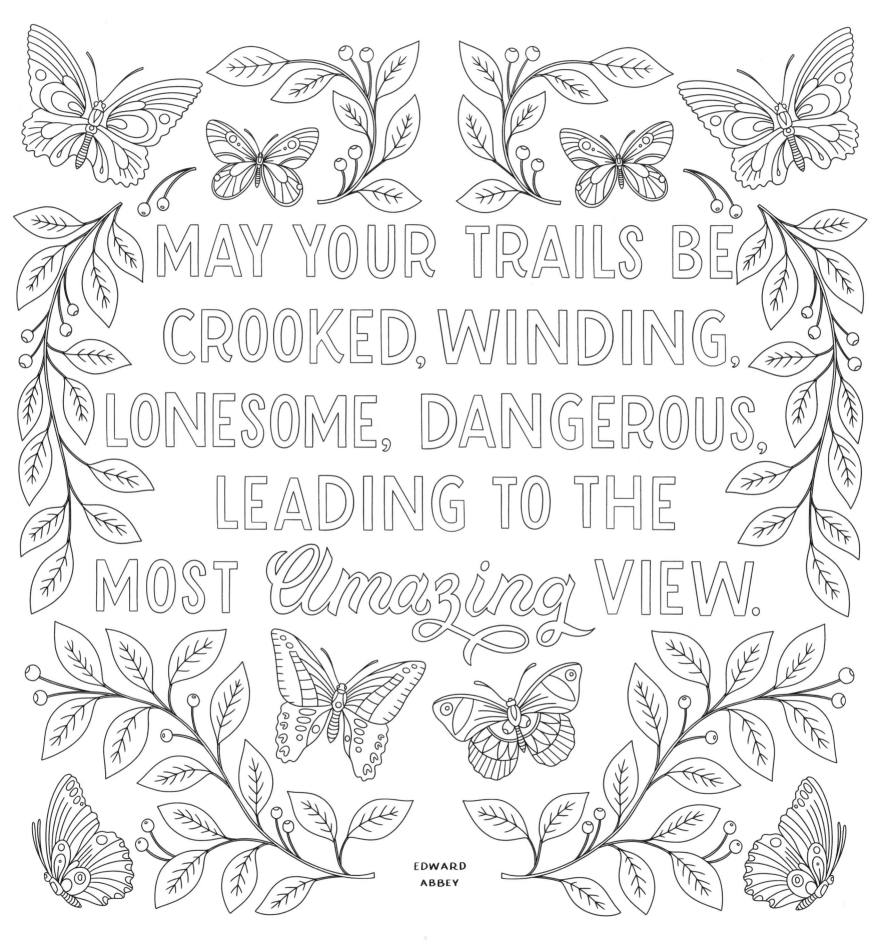

MAY YOUR TRAILS BE CROOKED, WINDING, LONESOME, DANGEROUS, LEADING TO THE MOST *Amazing* VIEW.

EDWARD ABBEY

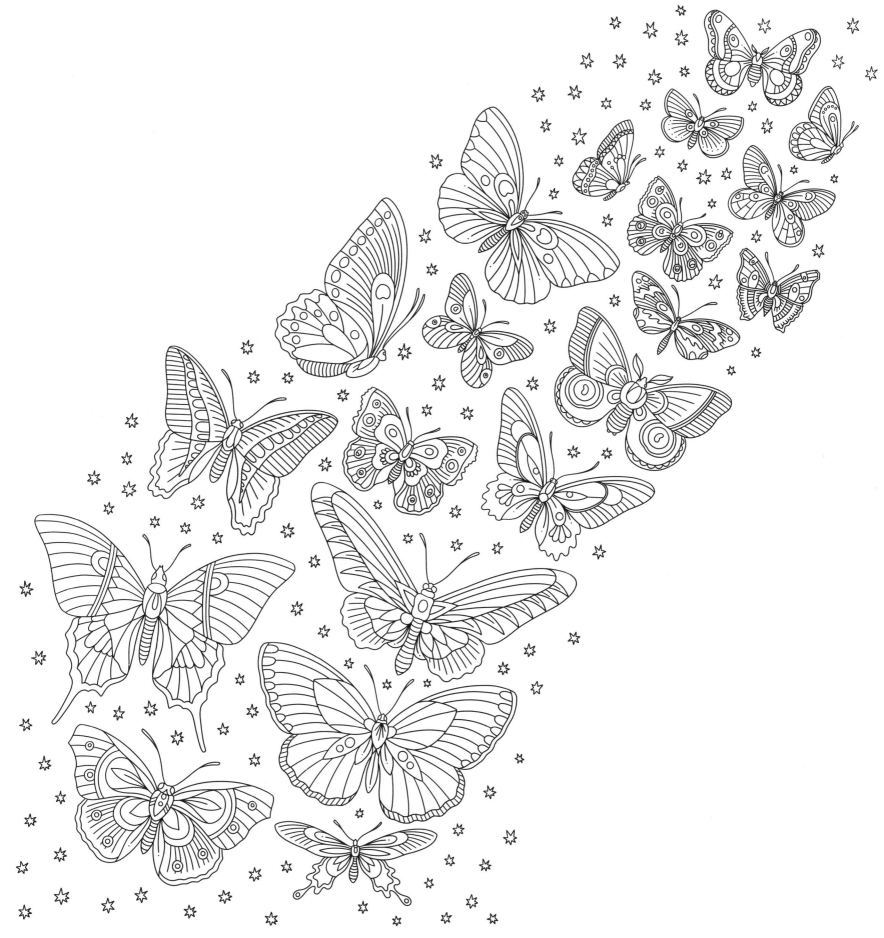

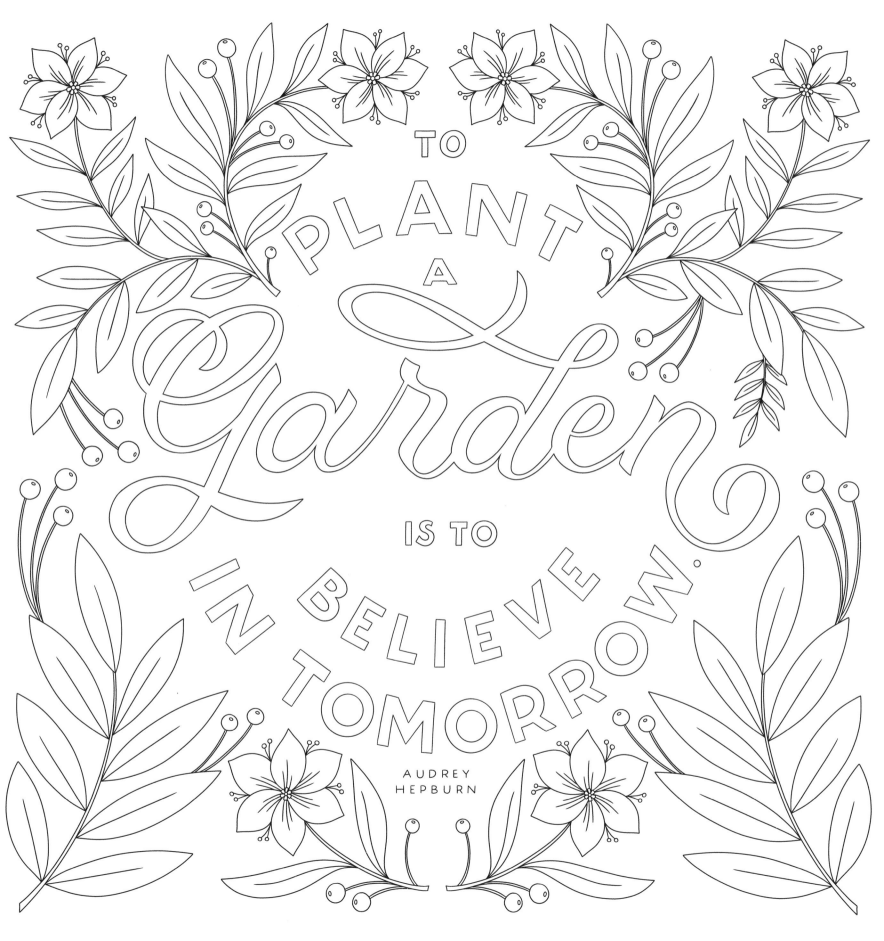

TO PLANT A *Garden* IS TO BELIEVE IN TOMORROW.

AUDREY HEPBURN

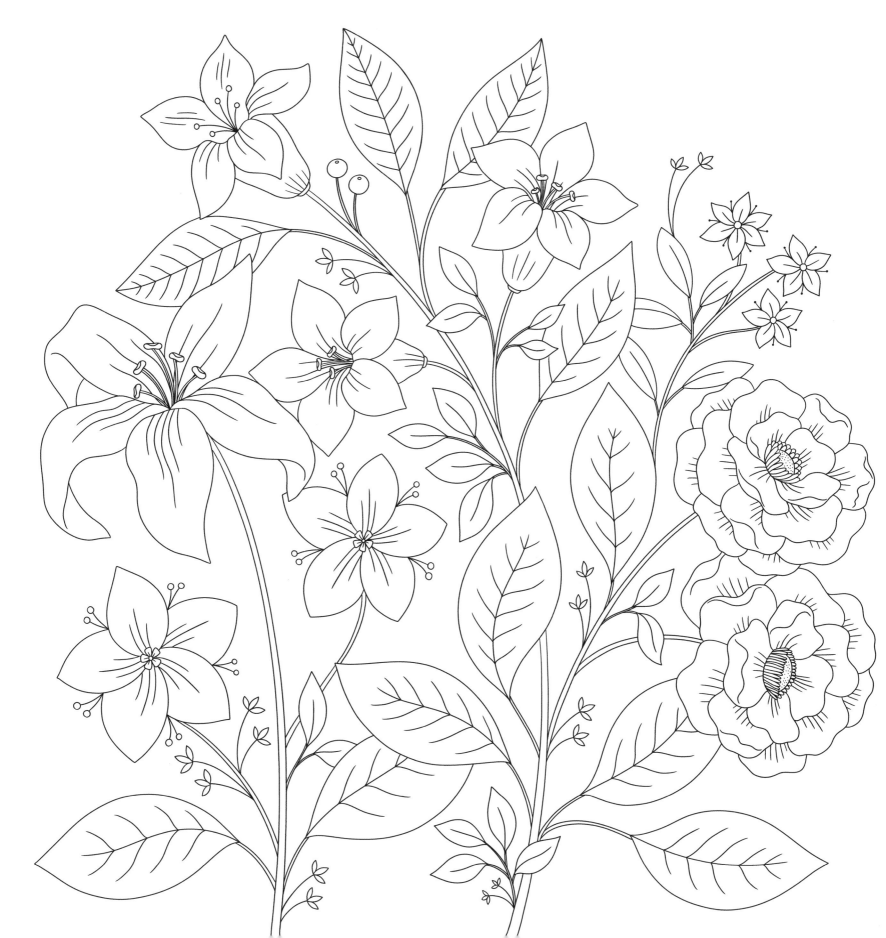

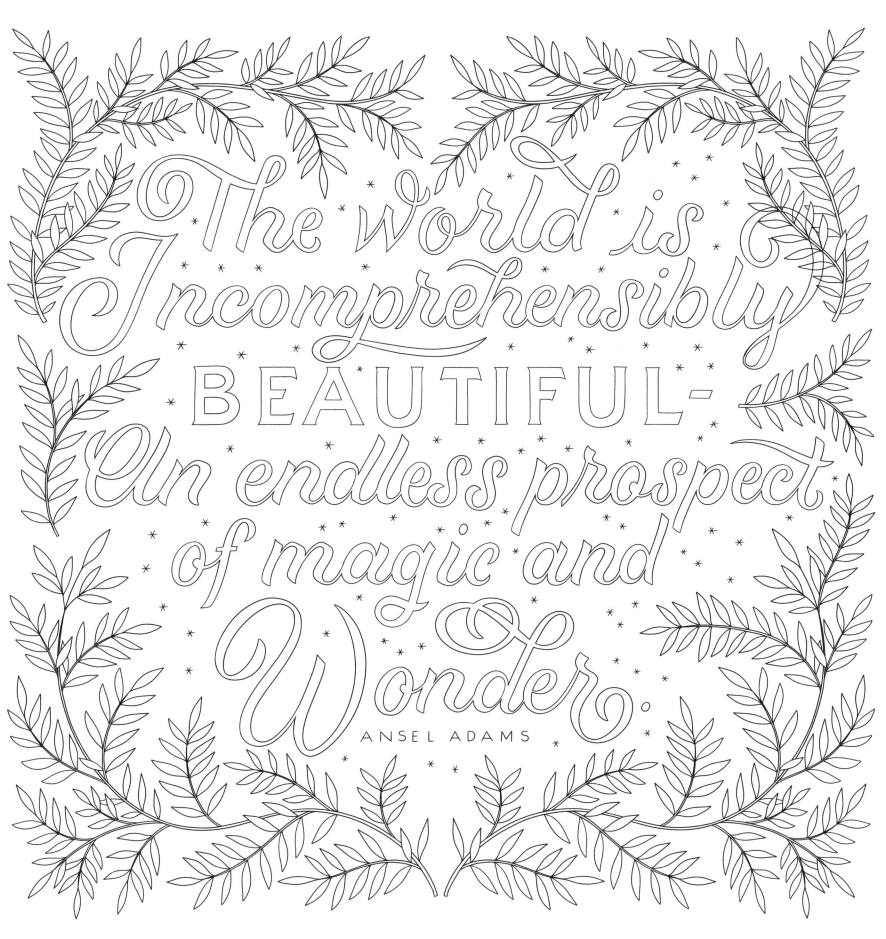

The world is Incomprehensibly BEAUTIFUL· An endless prospect of magic and Wonder.

ANSEL ADAMS

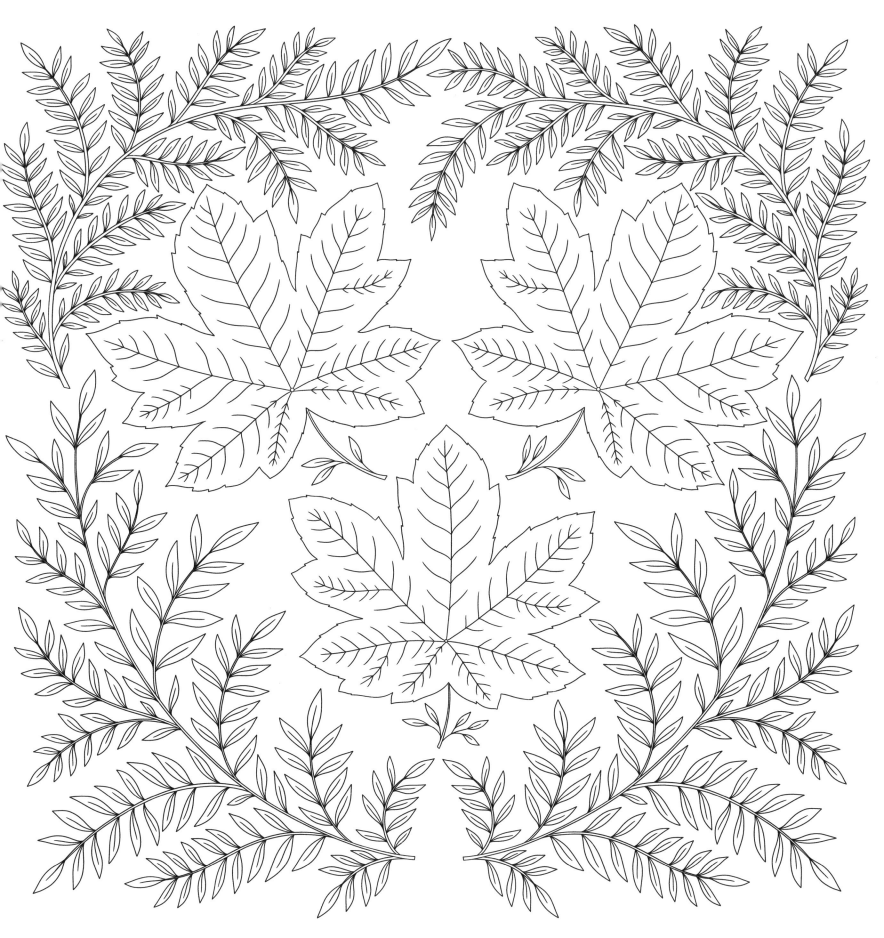

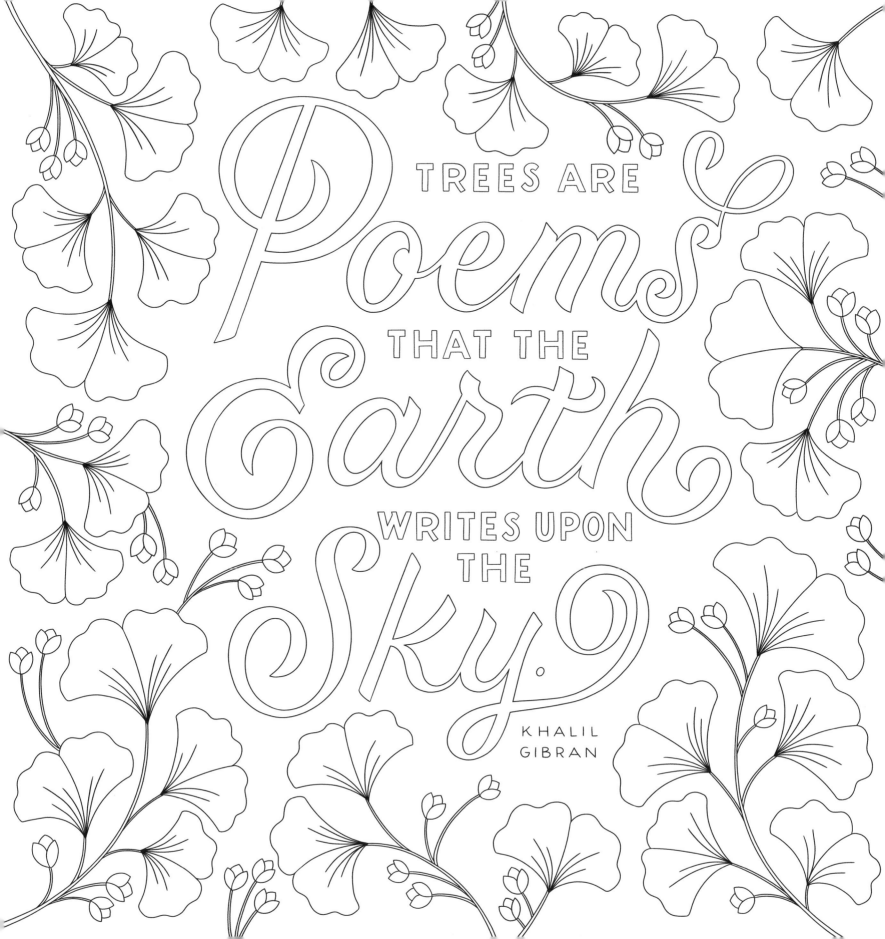

TREES ARE
Poems
THAT THE
Earth
WRITES UPON
THE
Sky.

KHALIL
GIBRAN

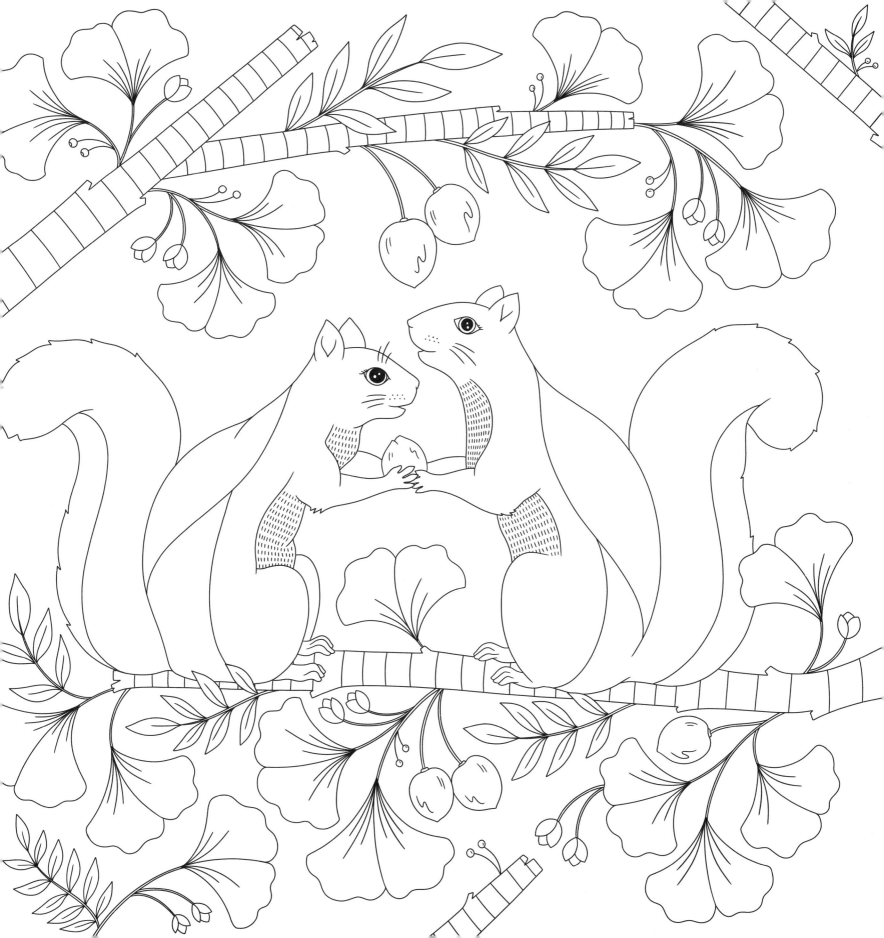

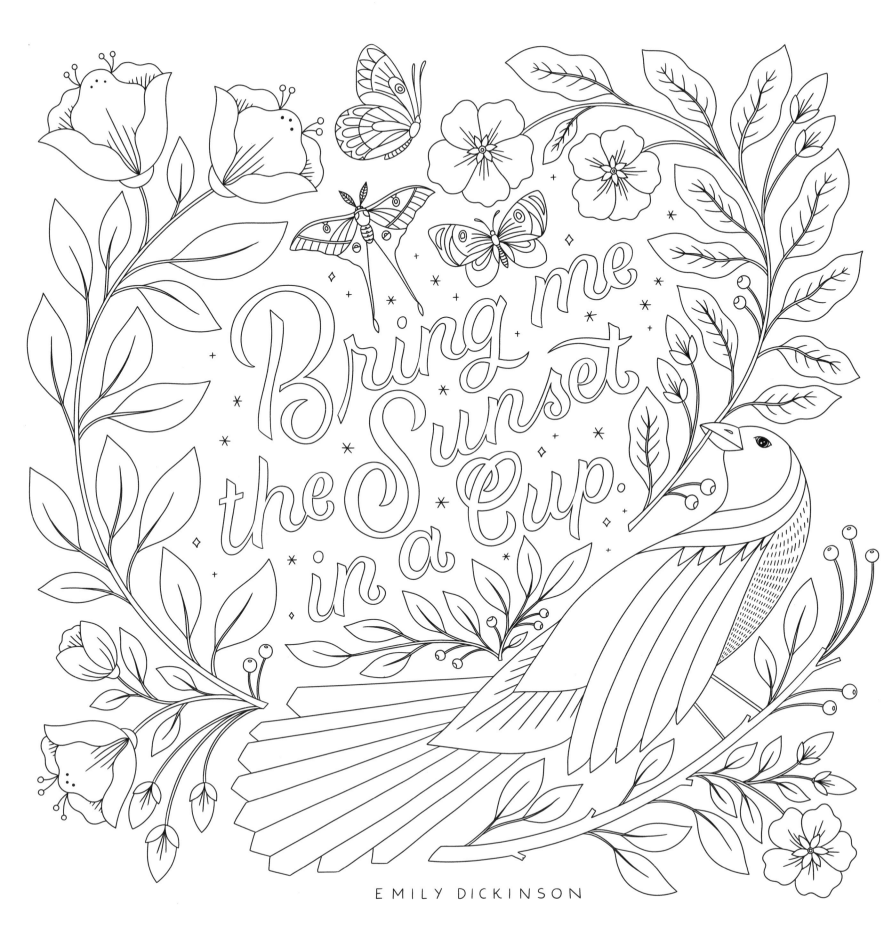

Bring me the Sunset in a Cup.

EMILY DICKINSON

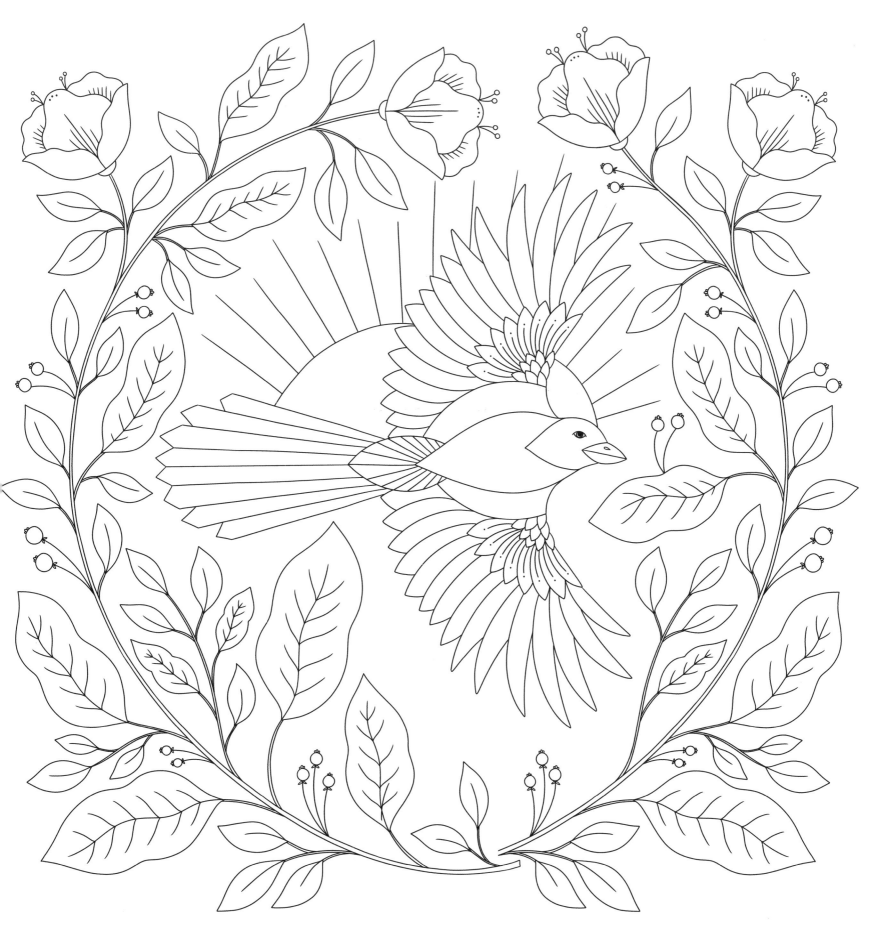

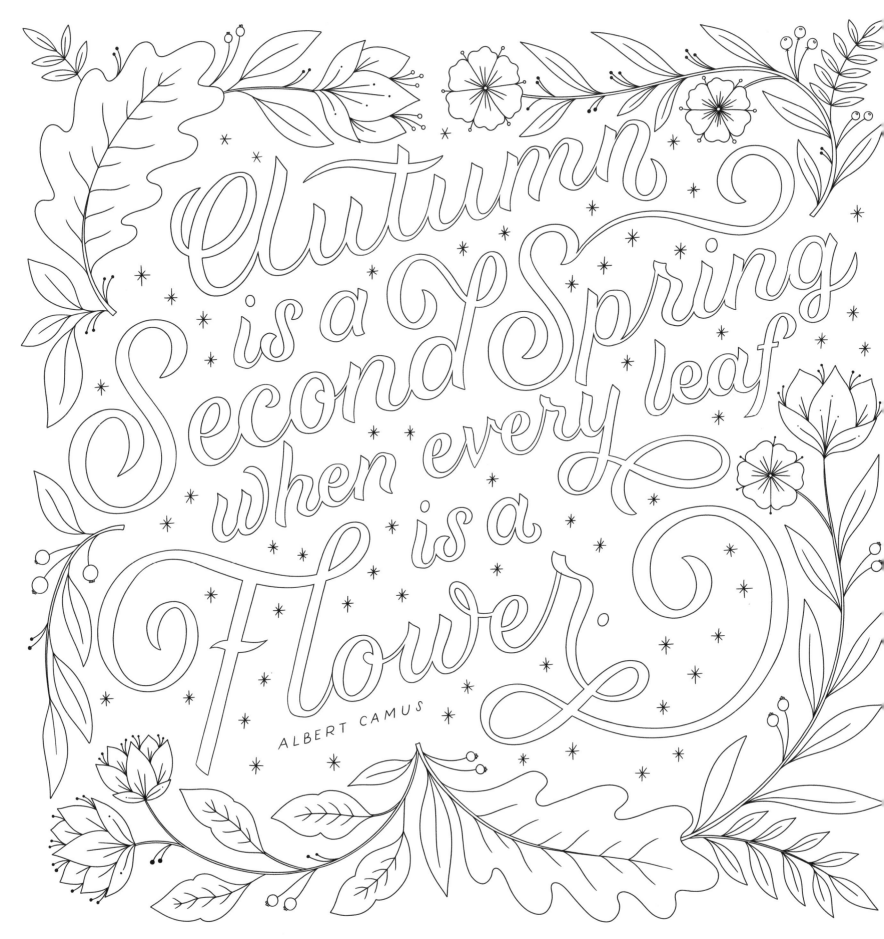

Autumn is a Second Spring when every leaf is a Flower.

ALBERT CAMUS

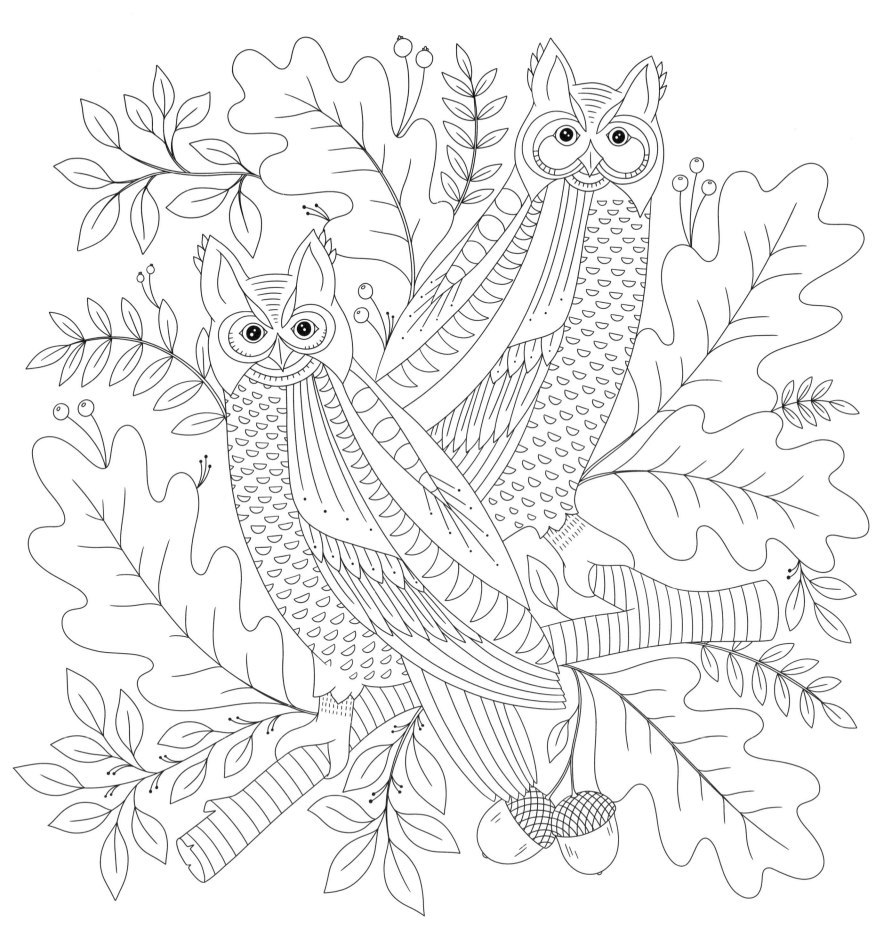

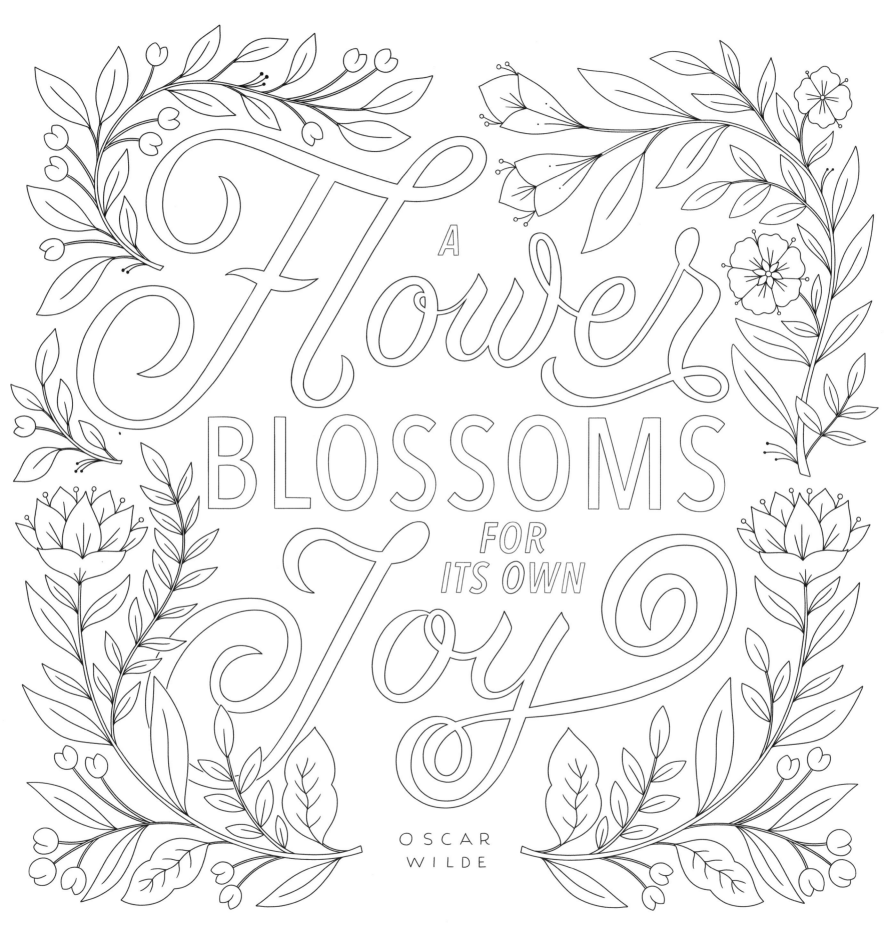

A Flower
BLOSSOMS
FOR
ITS OWN
Joy

OSCAR
WILDE

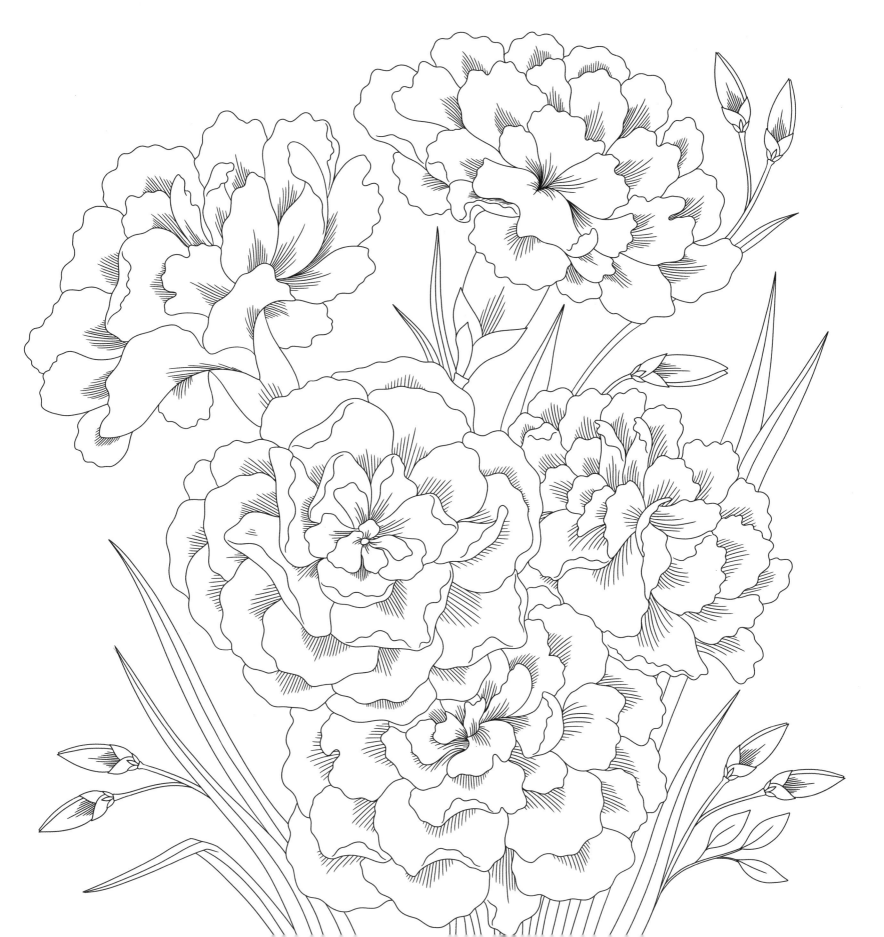

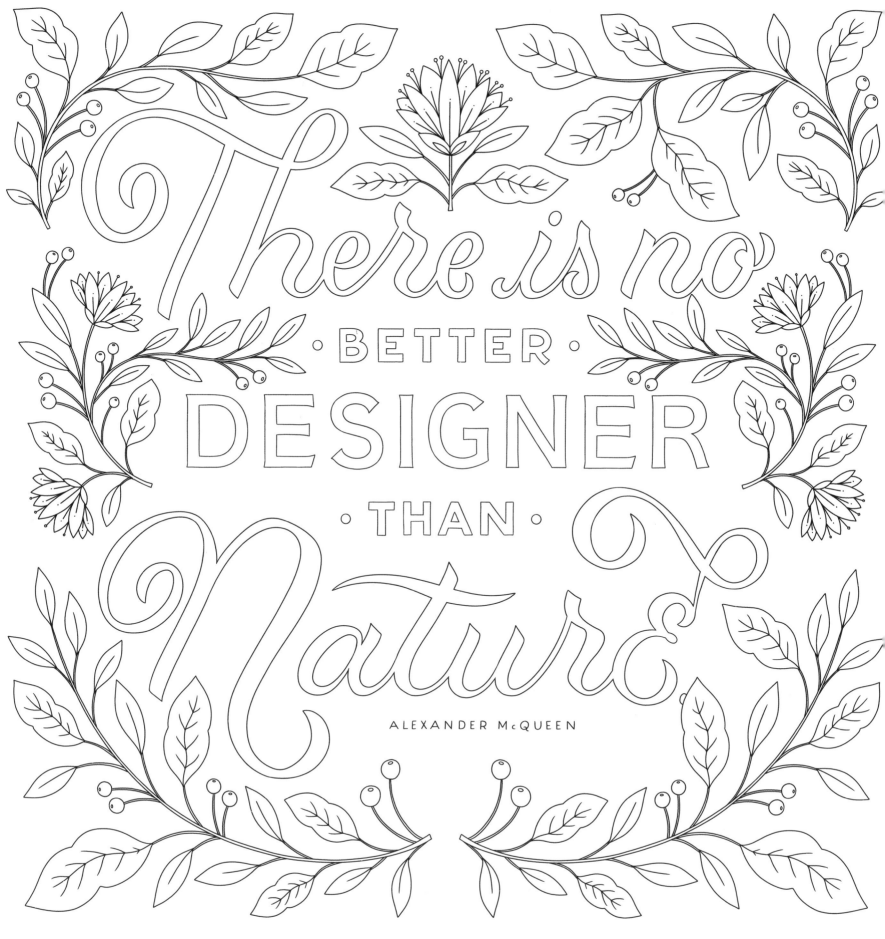

There is no BETTER DESIGNER THAN Nature

ALEXANDER McQUEEN

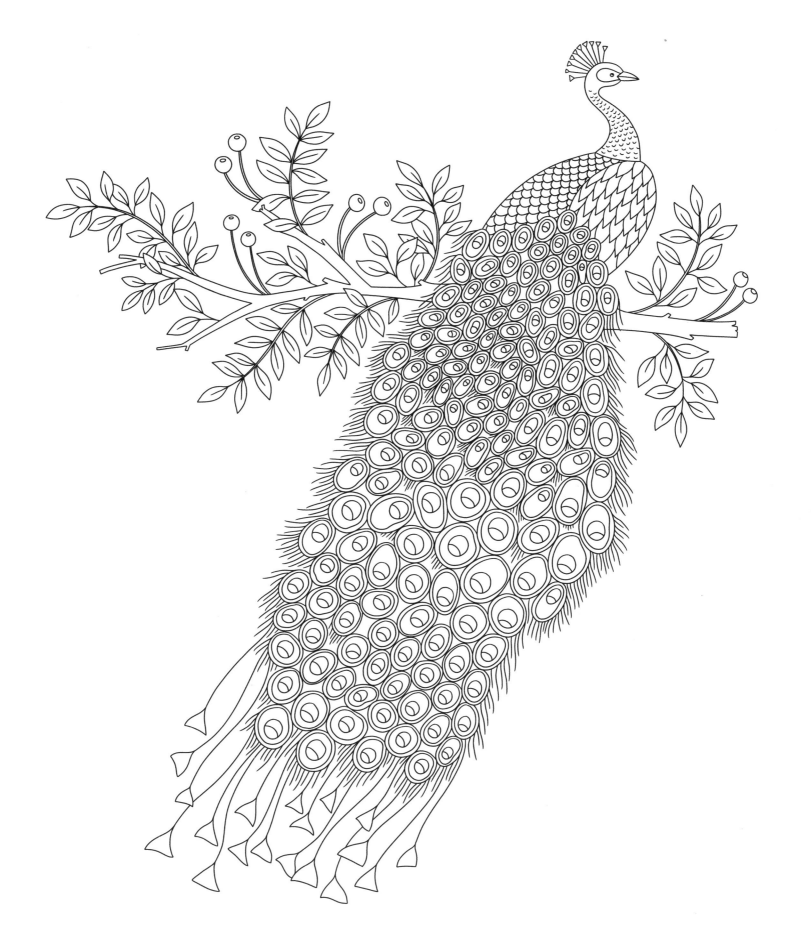

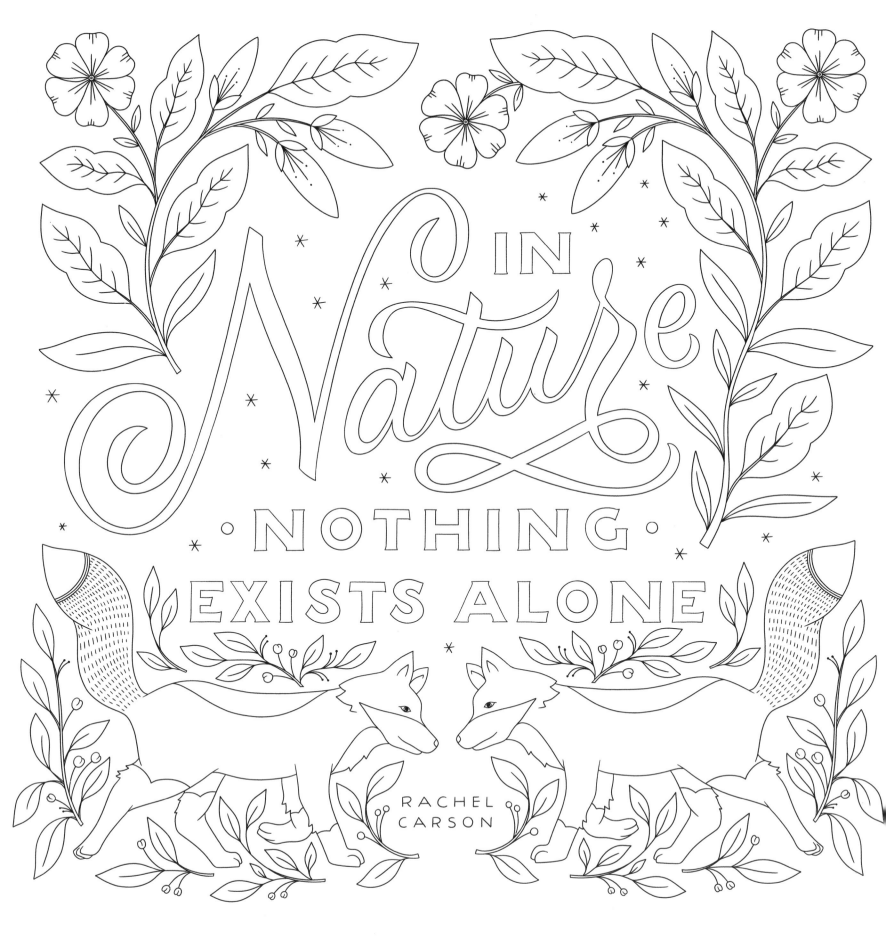

IN Nature NOTHING EXISTS ALONE

RACHEL CARSON

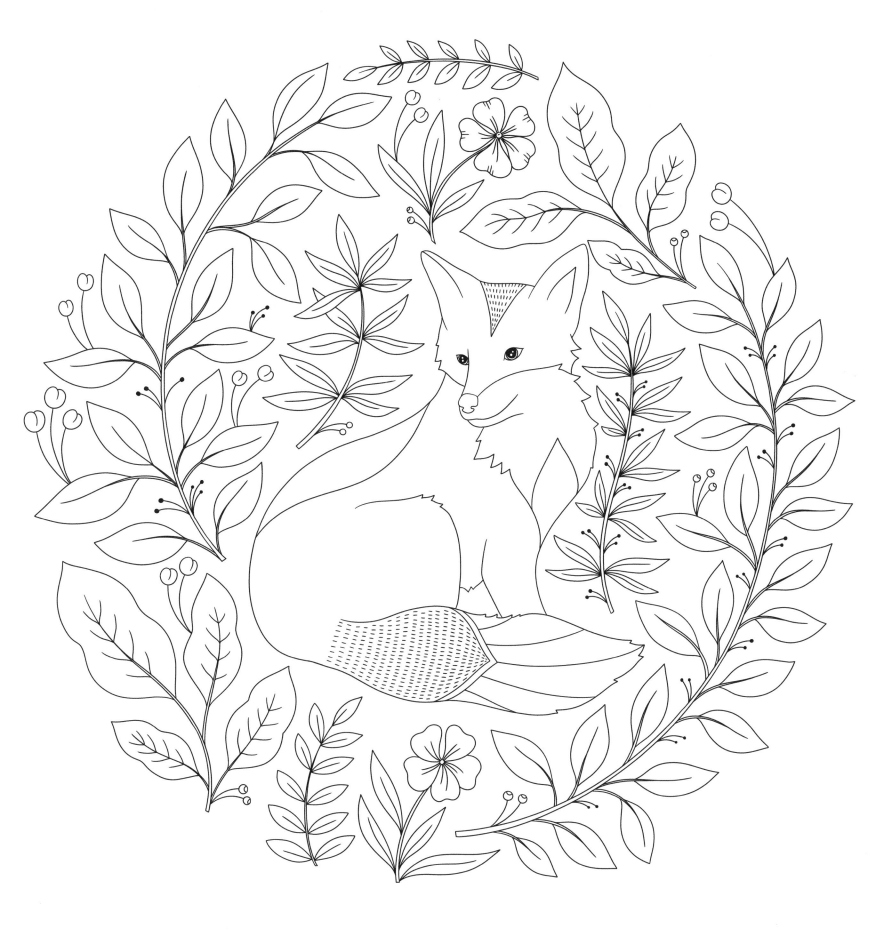

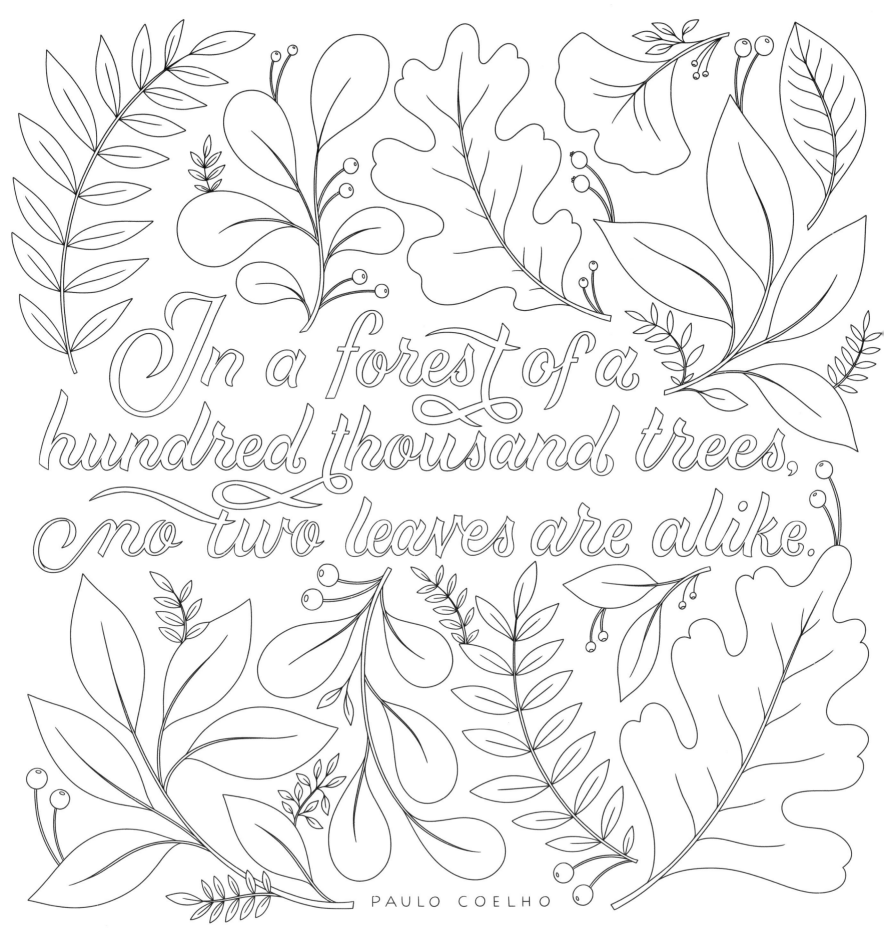

In a forest of a hundred thousand trees, no two leaves are alike.

PAULO COELHO

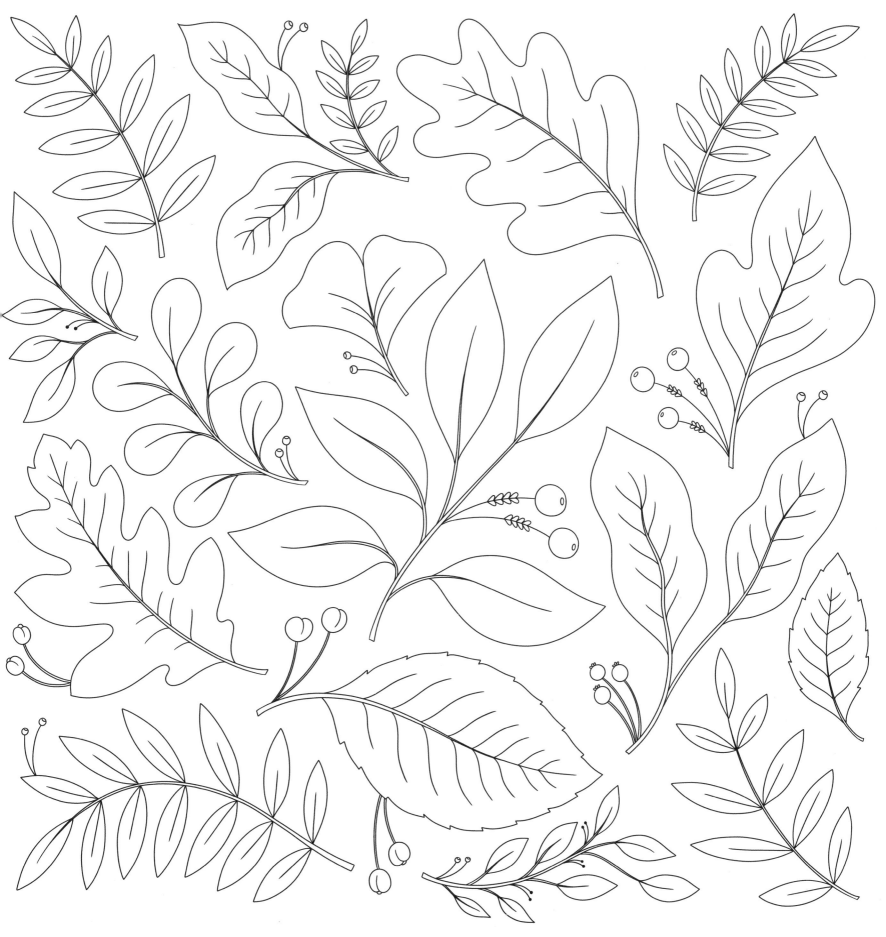

THERE ARE SOME WHO
CAN LIVE WITHOUT
WILD THINGS
& SOME WHO CANNOT.

ALDO
LEOPOLD

Delicious AUTUMN! My very soul is wedded to it.

GEORGE ELIOT

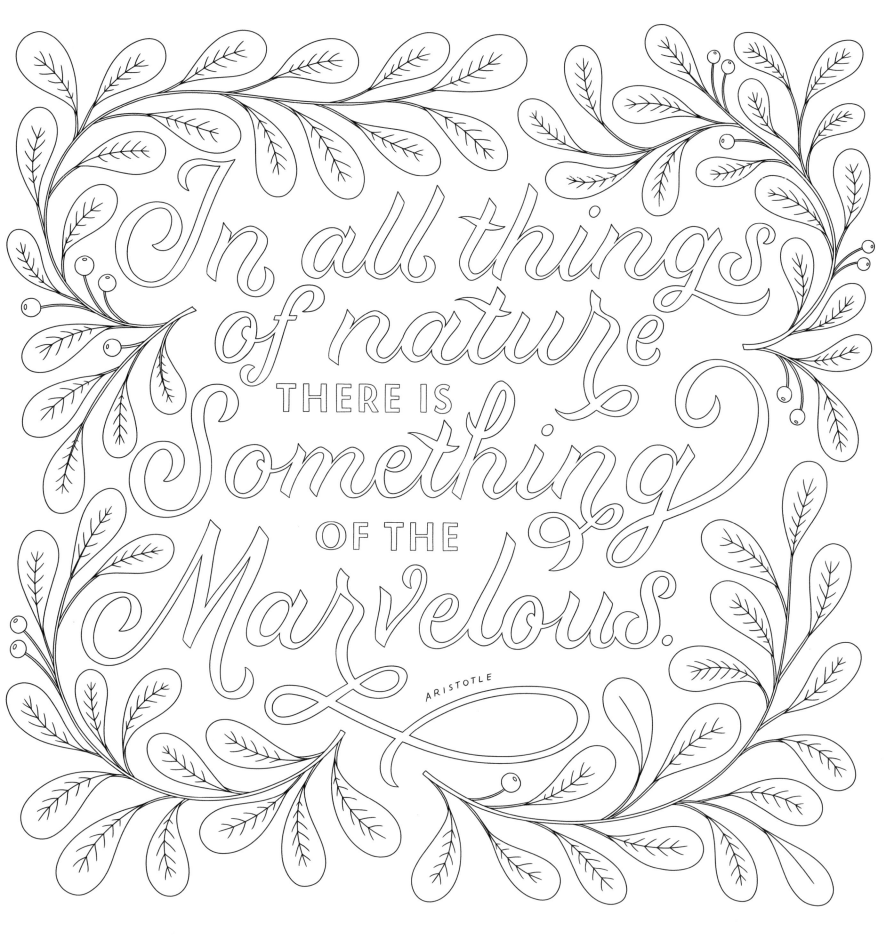

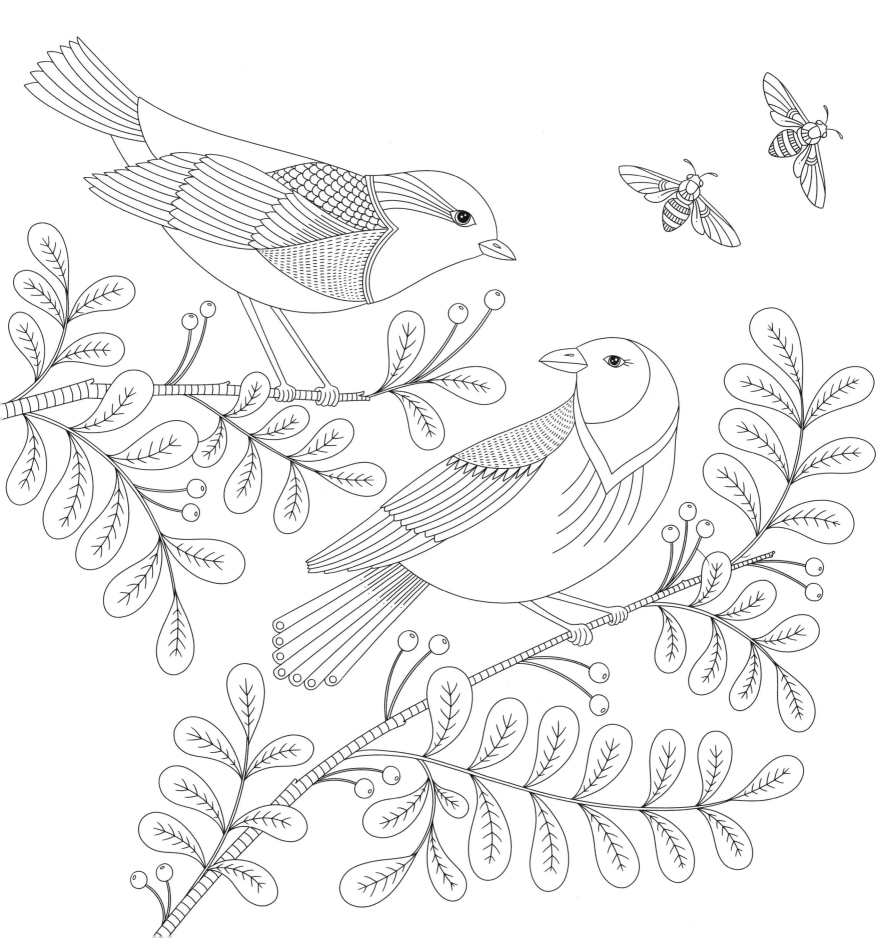

AND THEN MY HEART WITH PLEASURE FILLS, AND DANCES WITH THE DAFFODILS.

WILLIAM WORDSWORTH

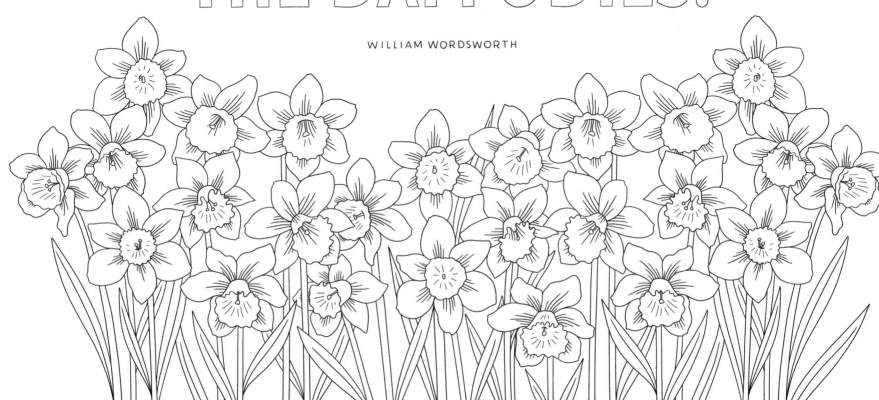

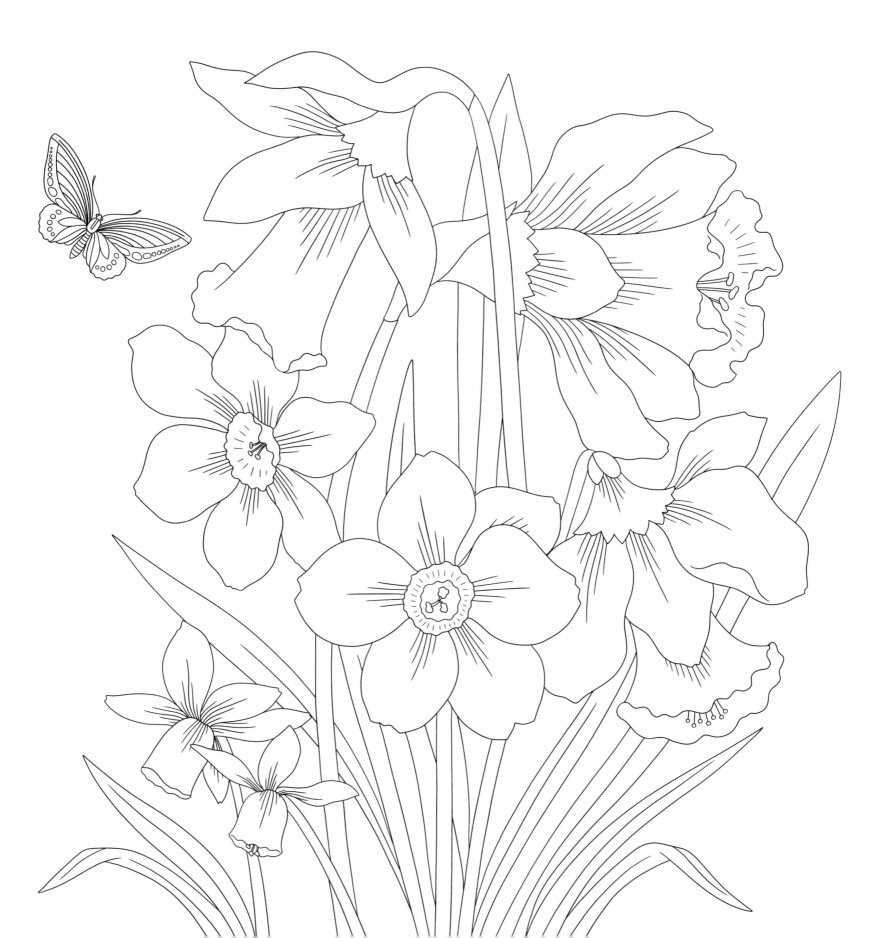

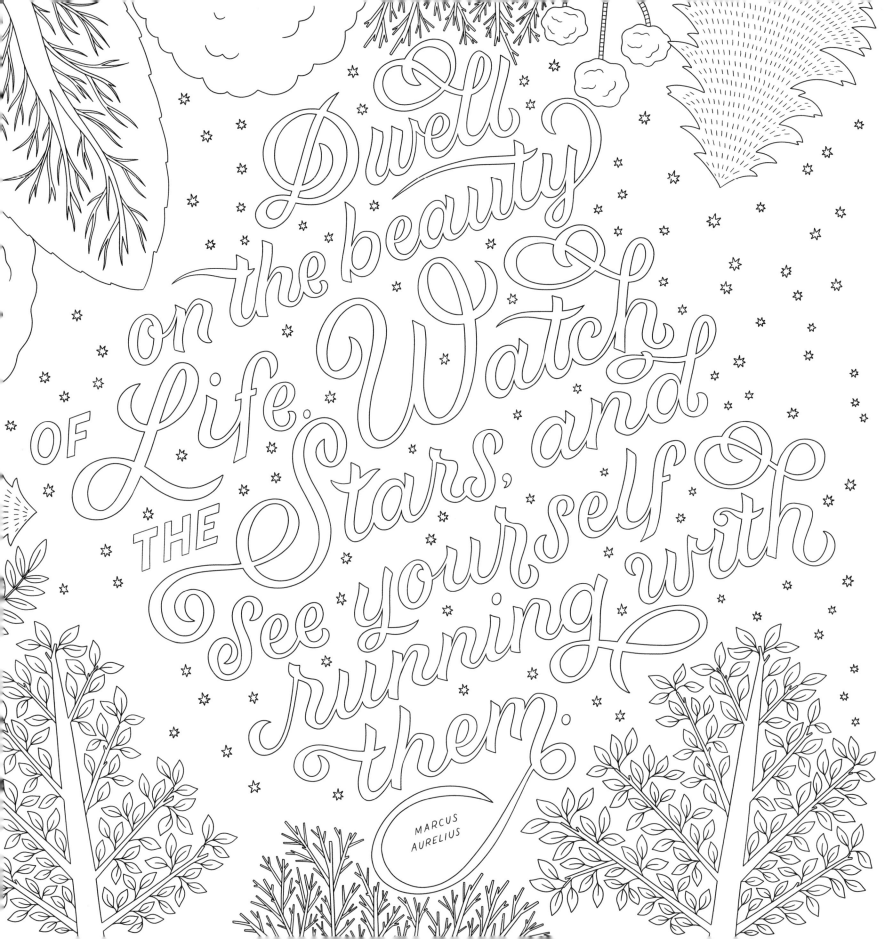

Dwell on the beauty of Life. Watch the Stars, and See yourself running with them.

MARCUS AURELIUS

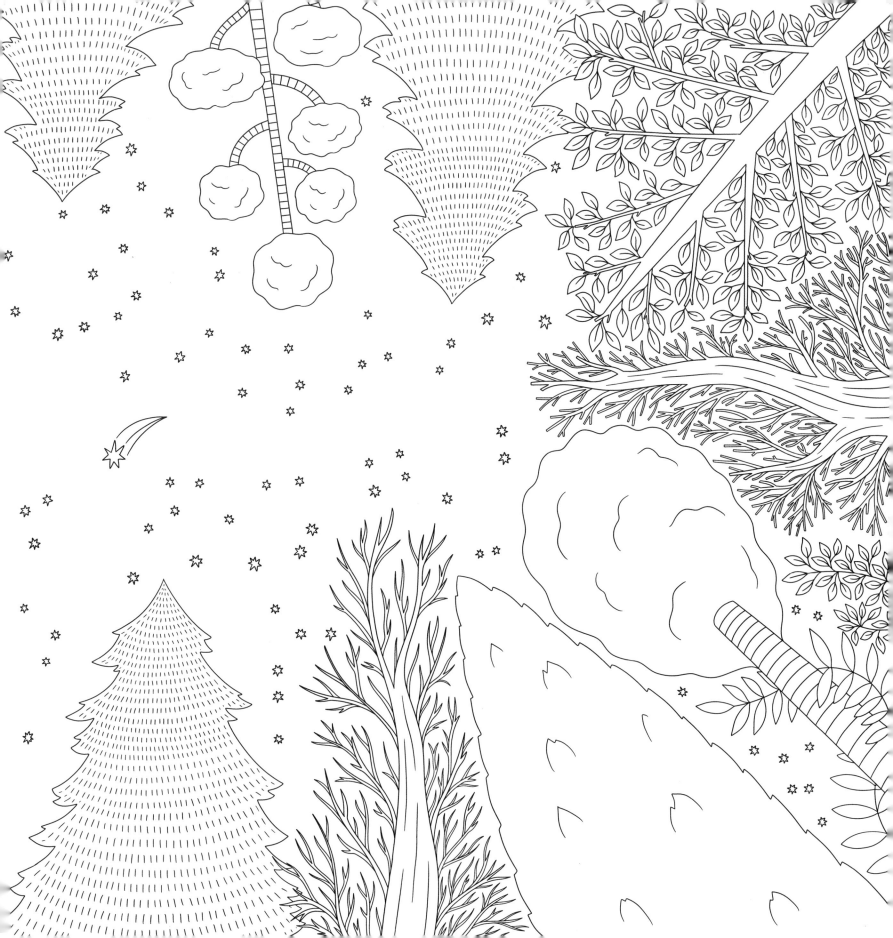

About the Illustrator

Margaret Kimball is an illustrator who has worked with
Penguin Random House, Little, Brown and Company,
Simon & Schuster, *Smithsonian* magazine, Macy's, Ogilvy,
and many other clients. Her first coloring book, *Birds &
Botanicals*, was published in 2016. She is the illustrator
of *All Things Bright & Beautiful* (Get Creative 6, 2018).
Her first graphic memoir, *And Now I Spill the Family Secrets*,
will be published by HarperOne in 2021. She lives with
her family in Indianapolis, Indiana.